take
me
there

DREAM, DRAW, and DESIGN
YOUR PERFECT ADVENTURE

TEXT AND WATERCOLOR
BY VICTOIRE BOURGOIS

ILLUSTRATIONS BY A. J. LIM

RUNNING PRESS
PHILADELPHIA

Running Press
Hachette Book Group
1290 Avenue of the Americas, New York, NY 10104
www.runningpress.com
@Running_Press

Printed in China

First Edition: January 2018

Published by Running Press, an imprint of Perseus Books, LLC,
a subsidiary of Hachette Book Group, Inc.

The Hachette Speakers Bureau provides a wide range of authors for speaking events.
To find out more, go to www.hachettespeakersbureau.com or call (866) 376-6591.

The publisher is not responsible for websites (or their content) that are not owned by the publisher.

Print book cover and interior design by Amanda Richmond.

Library of Congress Control Number: 2016956018

ISBN: 978-0-7624-6190-5

LSC-C

10 9 8 7 6 5 4 3 2 1

This book belongs to

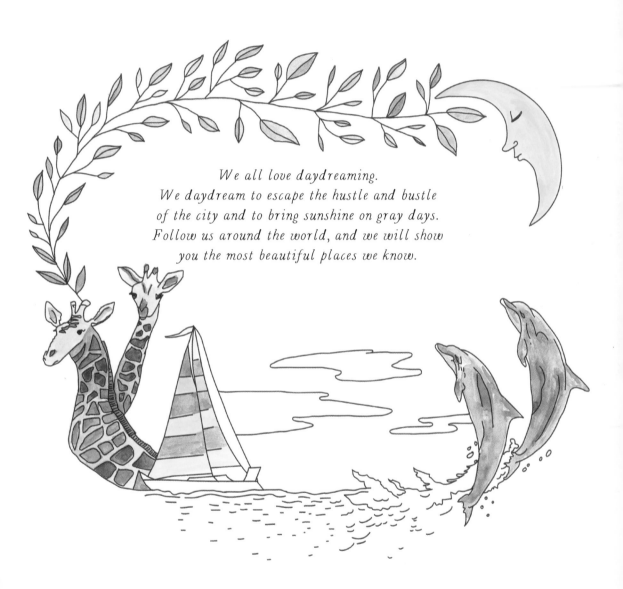

We all love daydreaming.
We daydream to escape the hustle and bustle
of the city and to bring sunshine on gray days.
Follow us around the world, and we will show
you the most beautiful places we know.

Take Me To...

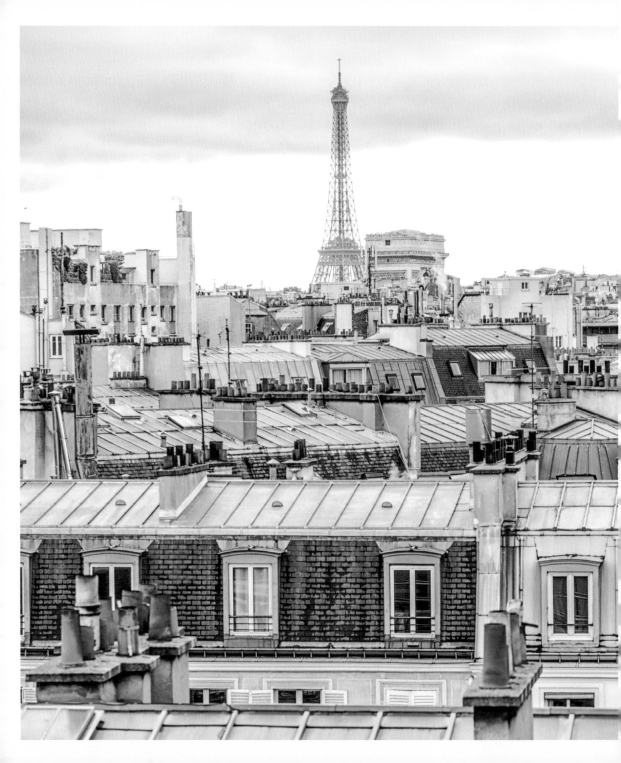

Paris, FRANCE

PARIS IS THE CITY OF LIGHT AND LOVE! A HOLIDAY IN PARIS MEANS slowing down to take a stroll along the Seine River and enjoying a café or an *apéro en terrasse* with some *saucisson* and *des cornichons, s'il vous plaît, monsieur*. Go to the Louvre and maybe you'll catch the *Mona Lisa* smiling discreetly. And if you go to the Place de la Bastille, walk to the Marché d'Aligre, where you will find beautiful fruit and vegetables, and market vendors will give you extra pieces for free just to make you smile.

Emmenez-moi au bout de la terre . . .

"Take Me Along to the Wonderland" is a song by lyricist and singer Charles Aznavour and is one of the many sources of inspiration for this book. Another is the imaginative spirit of poet Jacques Prévert. Both artists have delighted generations of French students. Look them up—you won't be disappointed!

Treat yourself to a bouquet of violettes, Simone de Beauvoir's *The Second Sex*, and a chocolate éclair. You don't need much to be as happy as a Parisienne.

What do you see when sitting
at the terrace of a Parisian café?

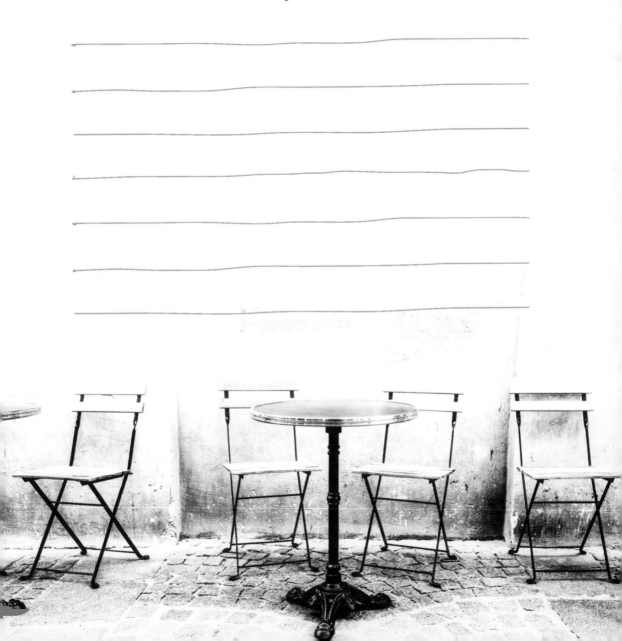

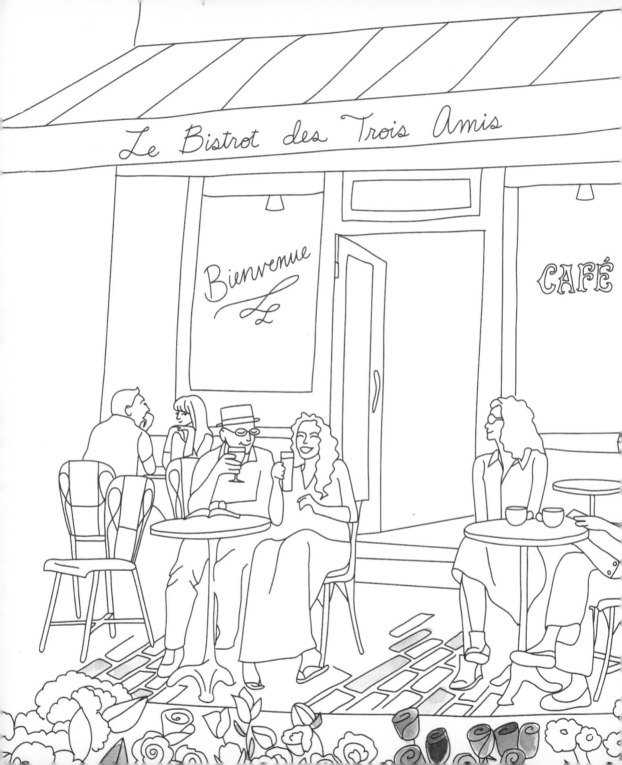

Imagine a dialogue between a man
and woman seated at a café.
What are they laughing about?

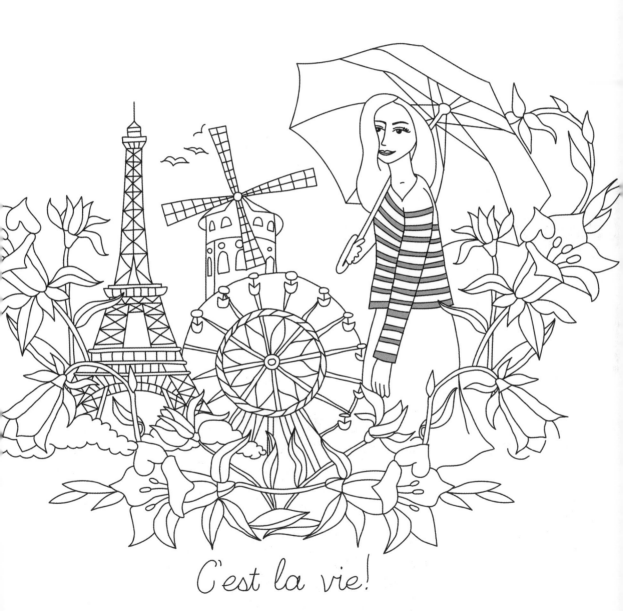

C'est la vie!

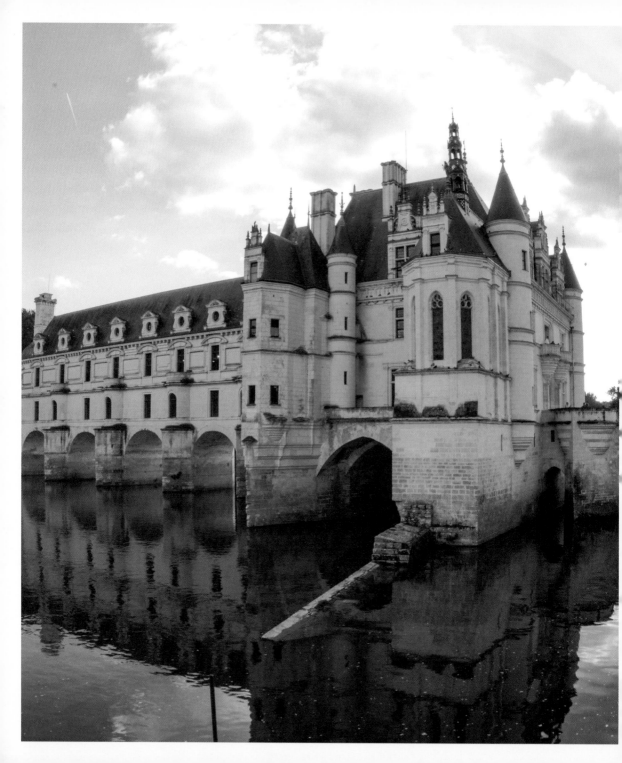

The Loire Valley, FRANCE

THIS MAGNIFICENT REGION, JUST A SHORT RIDE FROM PARIS, IS HOME to some of Europe's most beautiful castles. There are over three hundred châteaux, which were homes to the French monarchy and court. The Château de Chambord was built by King Francis I and consists of over four hundred rooms and eighty-four staircases, including a double-helix staircase recalling designs by Leonardo da Vinci. Among so many castles, it's hard to choose! Here are a few gems that are well worth *le détour*: Château de Blois, Château de Chenonceau, Château d'Ussé, and Château d'Amboise.

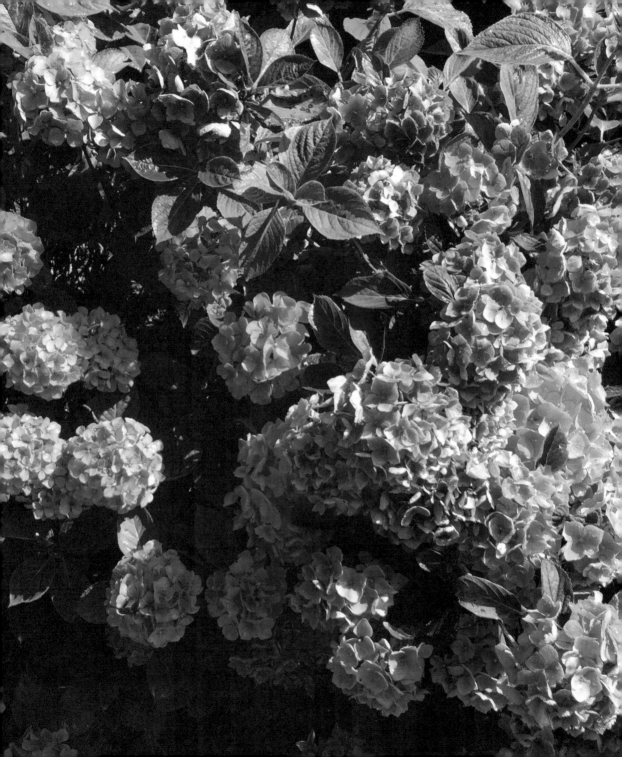

See these colorful hydrangeas?
They are plentiful in the Loire Valley.
Extend the hedge of flowers on this page.
You can use pink, purple, crimson, red, white,
and all sorts of green hues: lime green, dark
green, emerald green, and even blue green.

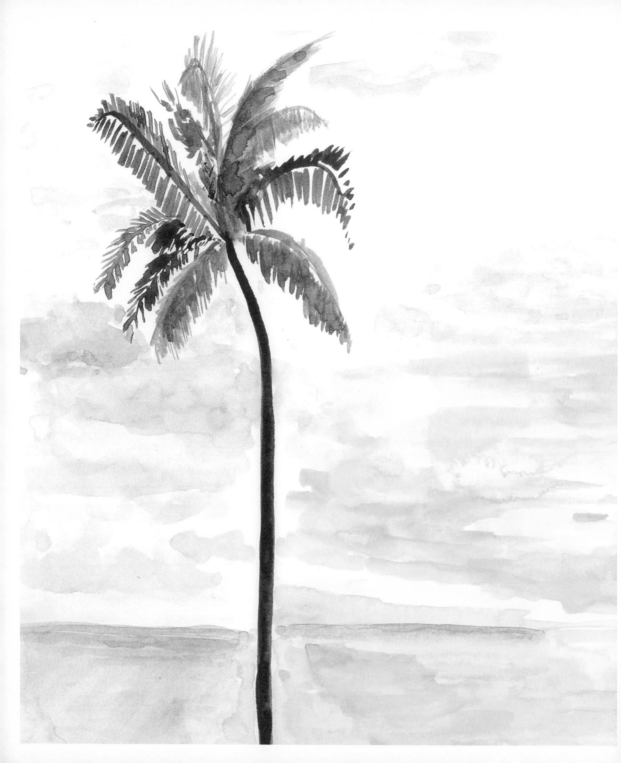

HAWAII, USA

HAWAII IS A GROUP OF ISLANDS FORMED AFTER A VOLCANIC eruption. It's famous around the globe for its golden-sand beaches lined with coconut trees, unspoiled landscapes, rich culture, and laid-back vibe. The lush landscape of Hawaii is filled with colorful flowers and rare birds. Watch whales migrate there for the winter months. And if you're up for it, catch gigantic waves on your surfboard!

Draw a castle fabulous enough to win
the annual sand castle competition!

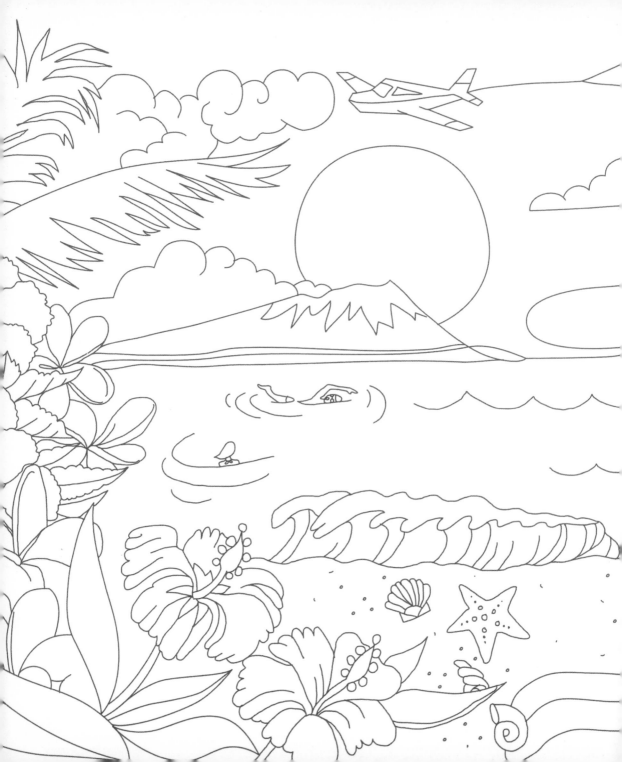

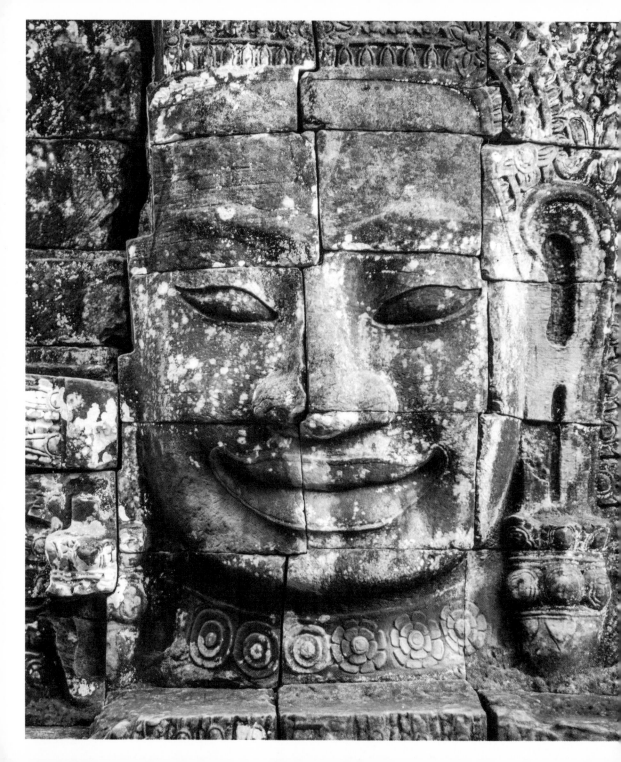

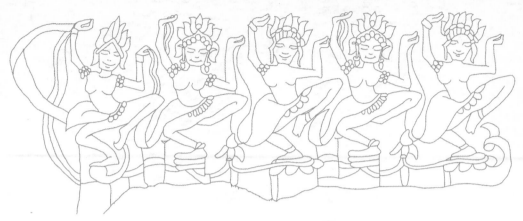

Angkor Wat, CAMBODIA

THE TEMPLES OF ANGKOR WAT ARE AMONG THE MOST FASCINATING **on** earth. They are decorated with scenes carved in stone. The walls are adorned with representations of *apsaras*, the celestial nymphs, and deities. There are thousands of them. Some of the smaller temples were abandoned for centuries and have now been completely taken over by nature. Giant trees sprout from the doorways of those still standing. Some temples look as though they were lifted from the ground by the tree roots as they grew and grew and grew.

Wake up before dawn and go see the sun rising over the main temple; the sight of the main structure and the orange sky reflected in the surrounding water basin is truly magical.

One of the most spellbinding temples, the Bayon, is covered with smiling stone faces. For centuries these have kept the same serene air. What is their secret? What are they smiling about?

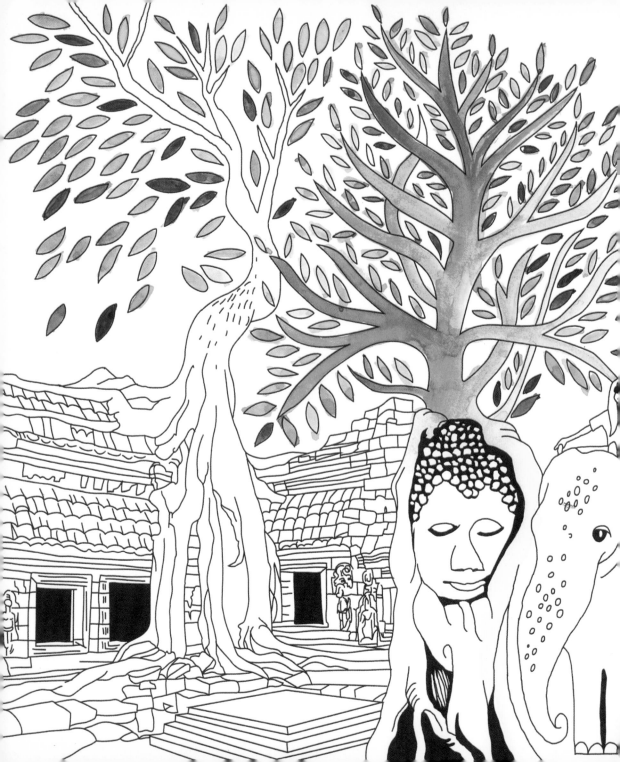

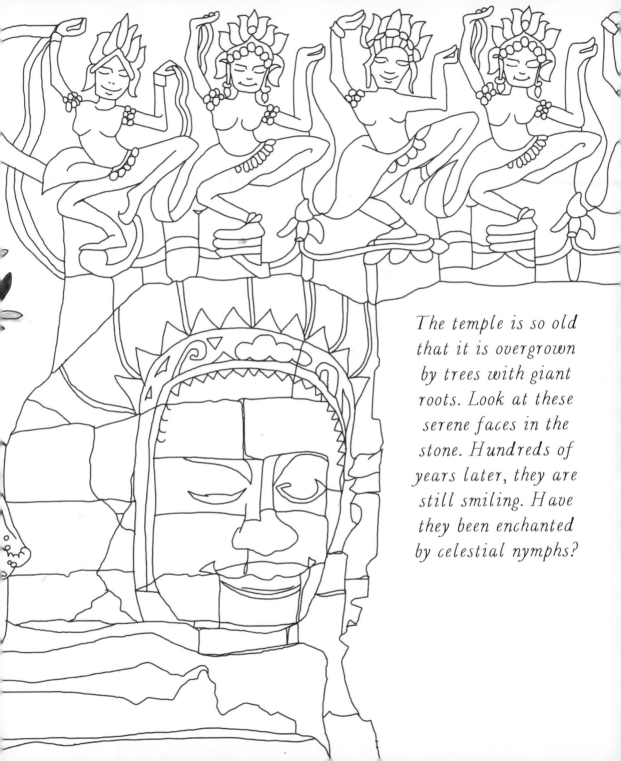

The temple is so old that it is overgrown by trees with giant roots. Look at these serene faces in the stone. Hundreds of years later, they are still smiling. Have they been enchanted by celestial nymphs?

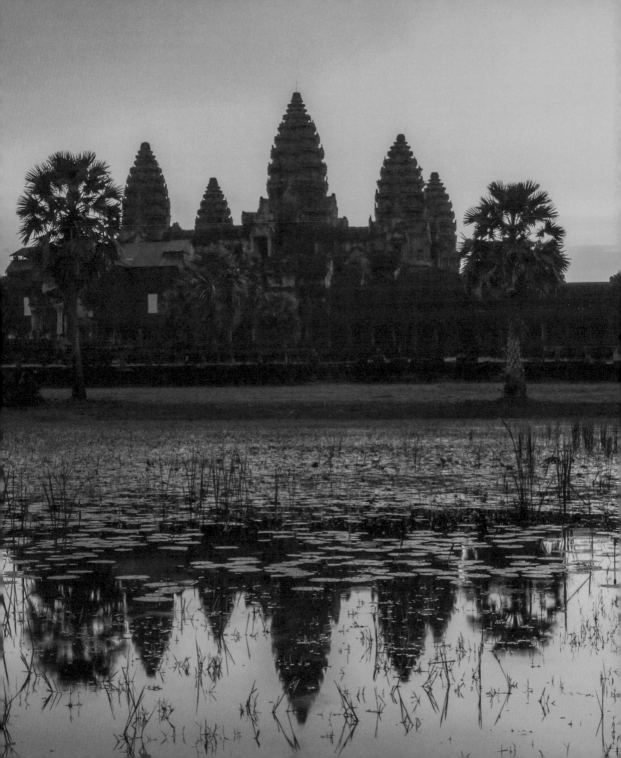

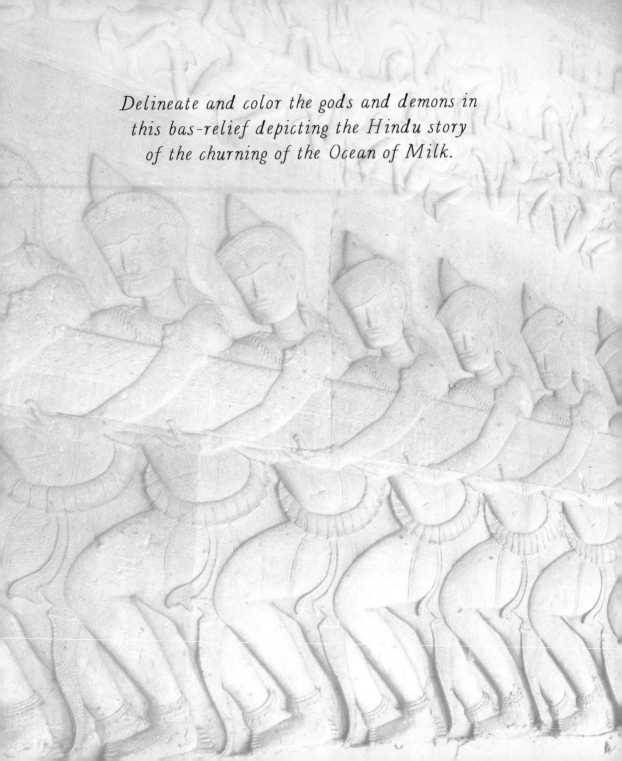

Delineate and color the gods and demons in
this bas-relief depicting the Hindu story
of the churning of the Ocean of Milk.

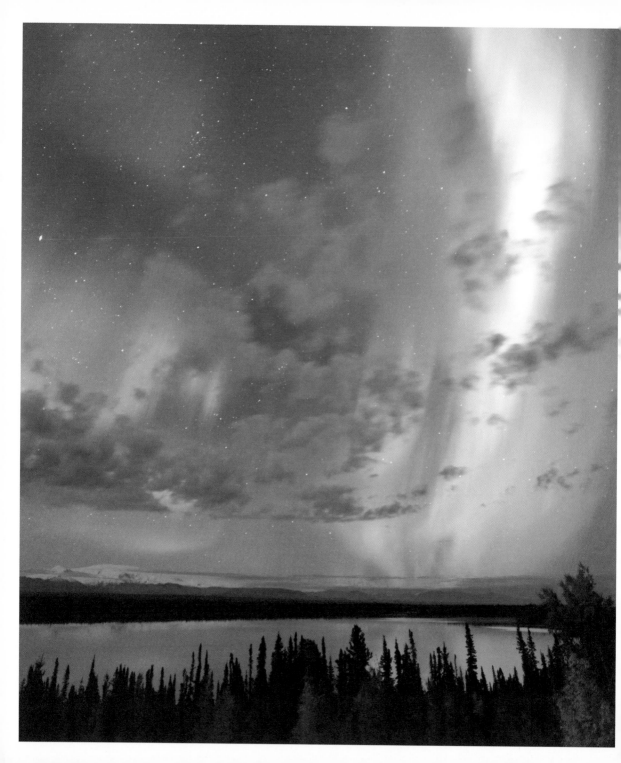

Fairbanks,
ALASKA, USA

THE AURORA BOREALIS IS THE GREATEST SHOW ON EARTH, AND THE tickets are free! The bright lights appear in various colors and shapes above the magnetic poles and manifest electrically charged particles from the sun that enter the earth's atmosphere. The best time to see them is on a clear night in winter.

*Have you ever seen
the northern lights?
It brings good luck!*

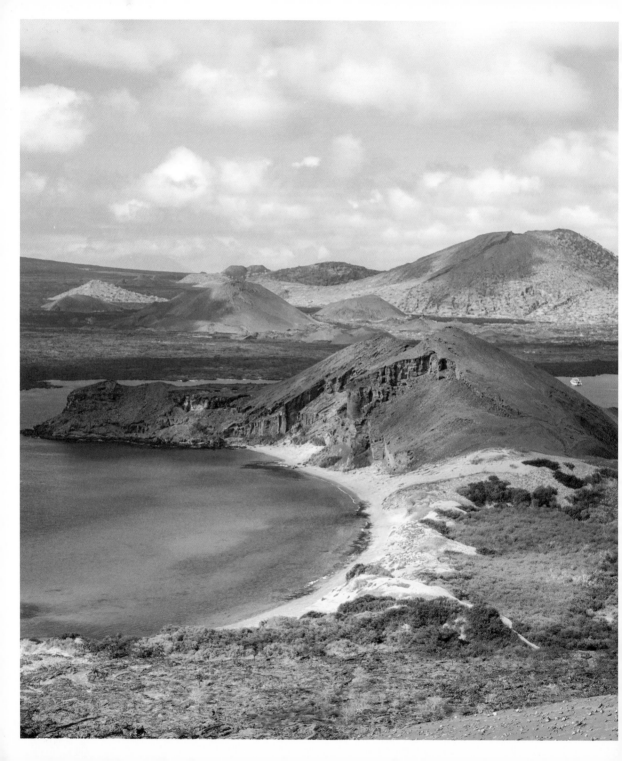

Galápagos Islands,
ECUADOR

HAVE YOU EVER SEEN TURQUOISE AND ULTRAMARINE SEAS? THIS
Ecuadorian island in the Pacific Ocean is well known for its unique wildlife. Darwin famously paid a visit to the Galápagos, and there he was inspired to develop his theory of evolution. Today you can see penguins, sea turtles, marine iguanas, sea lions, albatrosses, and many more species.

The kingdom of animals.
Shhh! Let's not disturb them.

Draw an iguana. Look up some photos of them first to help you capture some of their amazing colors!

MAINE, USA

AH, MAINE. THE SEA. THE SKY. THE SWELL. THE SURF. THINK LOBSTER
rolls and steamed clams. A kayak gliding among seagulls and seals. Climb up the tower
of a lighthouse and admire the surrounding view. And if it rains, cozy up with a good
book and a big sweater!

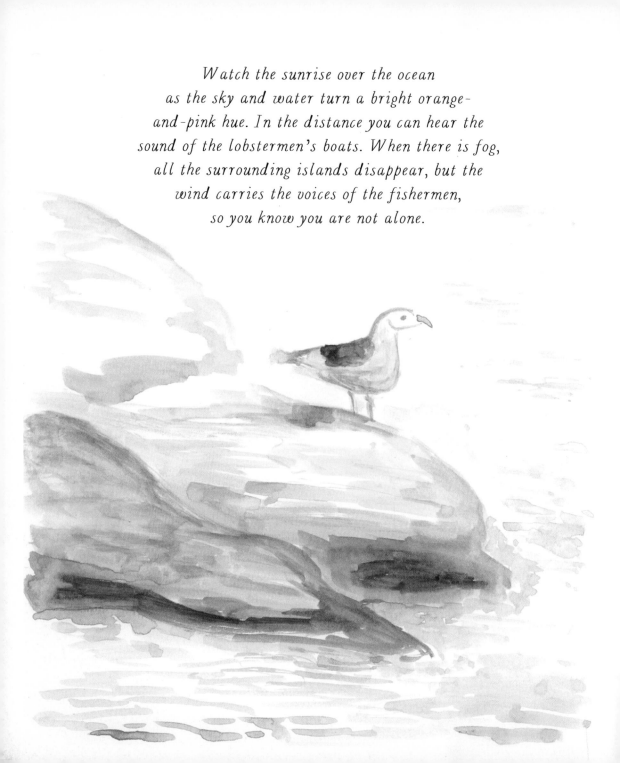

Watch the sunrise over the ocean
as the sky and water turn a bright orange-
and-pink hue. In the distance you can hear the
sound of the lobstermen's boats. When there is fog,
all the surrounding islands disappear, but the
wind carries the voices of the fishermen,
so you know you are not alone.

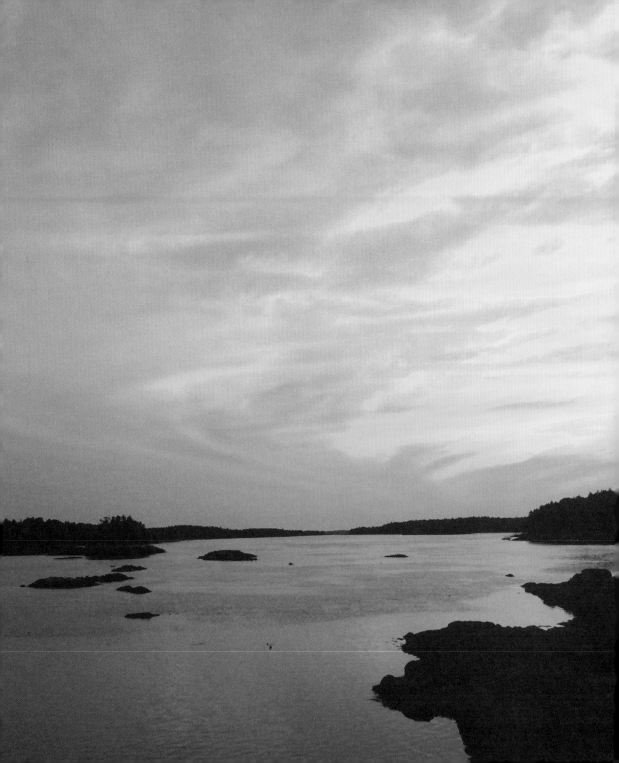

Can you imagine living in a lighthouse?
How would you spend your day there?

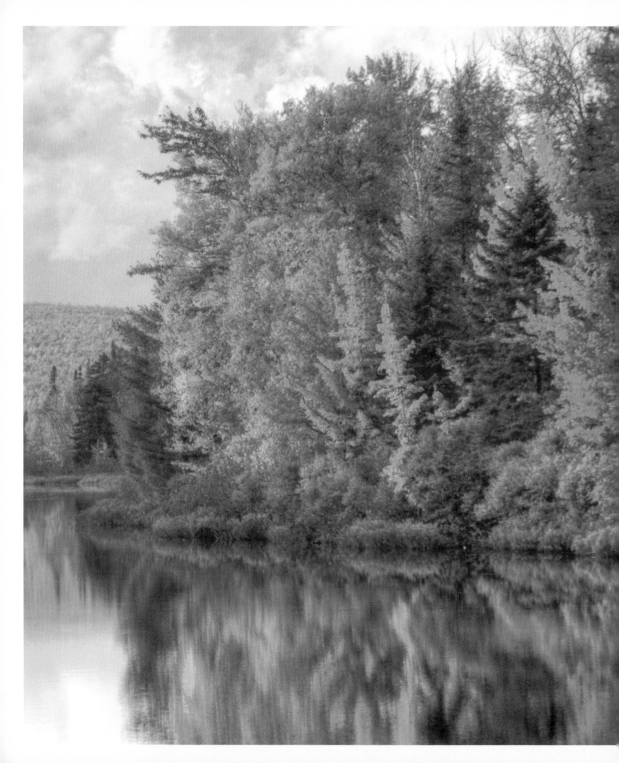

New England, USA

WHEN AUTUMN COMES, THE FOLIAGE OF NEW ENGLAND TURNS crimson red, orange, and gold. Entire forests are ablaze with color. The air is fresh: it's the perfect weather for a hike. Stop at a farm stand for crisp apples and a cup of hot apple cider. You can also pick your own pumpkins and carve them in time for Halloween!

New England

When autumn comes the trees are on fire.

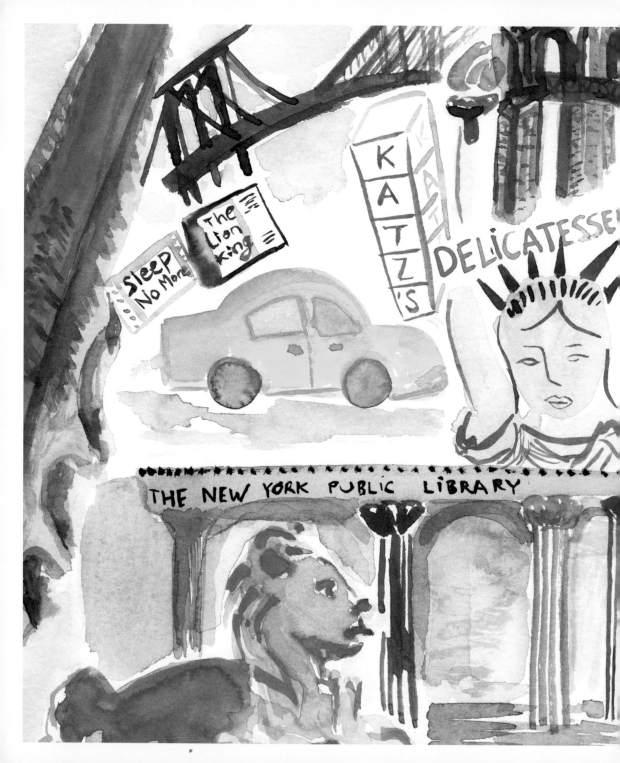

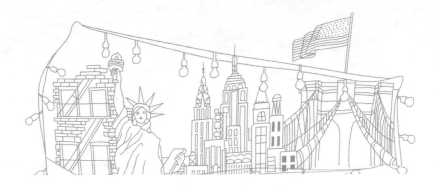

New York City, NEW YORK, USA

THE BIG APPLE ATTRACTS PEOPLE FROM ALL OVER THE WORLD. THIS is the city where in one neighborhood you can hear people speak English, Indian, Spanish, Arabic, Chinese, French, Creole, Greek, Korean, Polish, Russian, and Yiddish.

Go see an exhibition at the Museum of Modern Art and take a stroll in Central Park. Or go to Harlem to hear the most beautiful gospel voices and indulge in your cravings for soul food. You can even go all the way uptown to the Cloisters, if you'd like to see a piece of Europe in New York. Or walk along the High Line—formerly abandoned train tracks which are now covered with flowers and trees, providing the city with a garden in the air. And walk from Manhattan to Brooklyn across the Williamsburg Bridge to take in the gorgeous view. Who needs sleep when there is so much to do?

FILMS TO SEE

Manhattan (Woody Allen)

All About Eve (Joseph L. Mankiewicz)

Rear Window (Alfred Hitchcock)

West Side Story (Jerome Robbins and Robert Wise)

Desperately Seeking Susan (Susan Seidelman)

BOOKS TO READ

The Catcher in the Rye (J. D. Salinger)

Breakfast at Tiffany's (Truman Capote)

The Great Gatsby (F. Scott Fitzgerald)

Bright Light, Big Cities (Jay McInerney)

Open City (Teju Cole)

What is your favorite book
or movie about New York City?

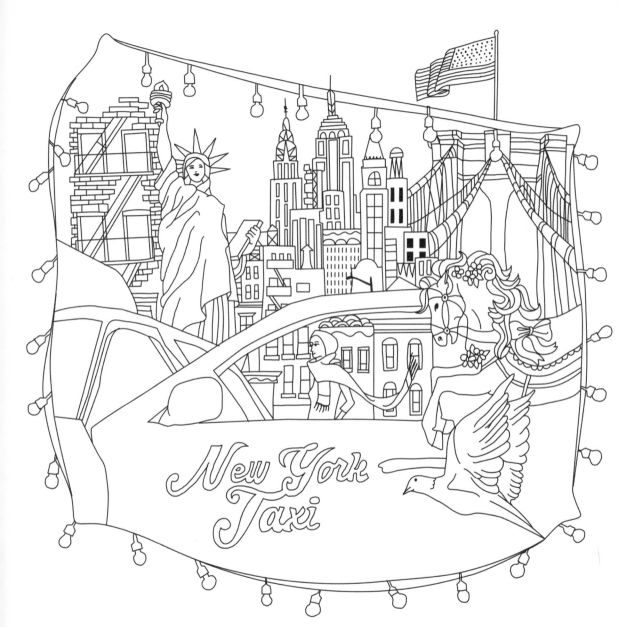

On my way down Broadway in the city that never sleeps

If you could live anywhere in
New York, where would it be?
Draw the facade of your building with
an arrow pointing to your apartment.

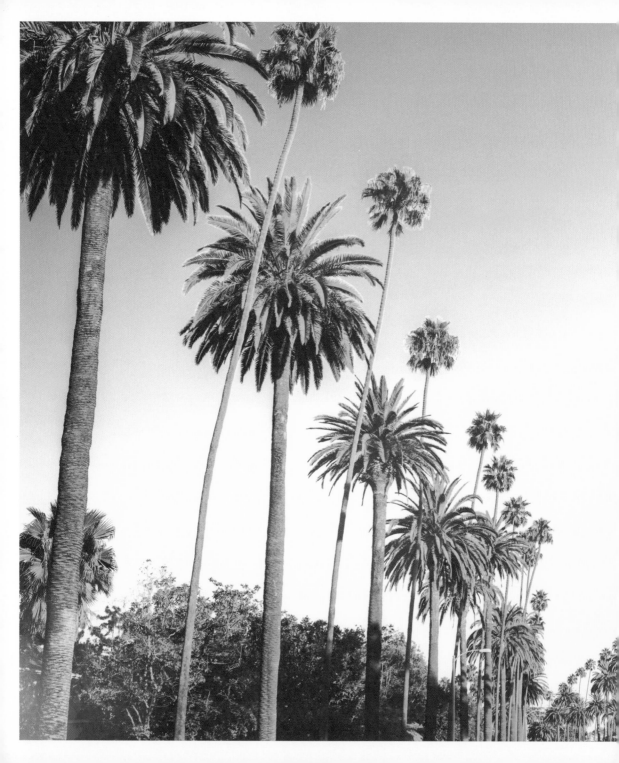

CALIFORNIA, USA

LEAVE ALL WORRIES BEHIND IN THE CITY AS YOU DRIVE ALONG THE
Pacific Coast Highway. Soon it is a mere dot in the distance and all you can see ahead
of you is the road, and the ocean. Play your favorite songs as you enjoy this moment of
sheer freedom. Once you reach the Bixby Bridge, you know you have entered Big Sur,
a place that drew Beat generation poets and now attracts nature lovers. Keep going
and watch the landscape transform. A few hours later you will reach Los Angeles—the
city of dreams; go to the observatory and think of James Dean and Natalie Wood in
Rebel Without a Cause. Keep driving and head to Malibu, accompanied by the sound
of the waves crashing. At Point Dume, look at the sunset as you listen to the waves
and look at the birds fishing. It's the most magical sunset.

Coachella in Indio

EVERY YEAR IN THE CALIFORNIA DESERT, THE COACHELLA VALLEY
Music and Arts Festival takes place, drawing crowds of music lovers. Who would you like to see onstage?

Coachella Music Festival

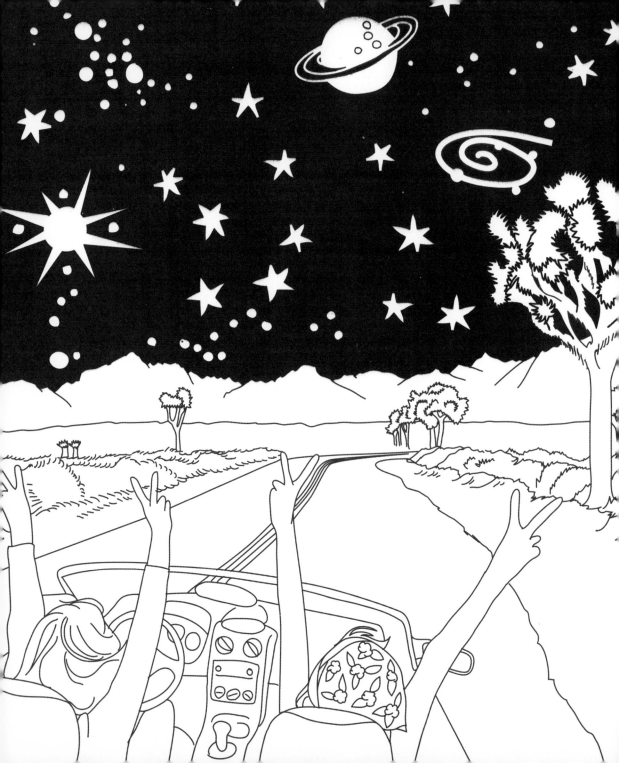

The ultimate road trip in Southern California would not be complete without seeing starry skies at night over the desert and admiring cacti by day along the road.

Draw your favorite shape of cacti!

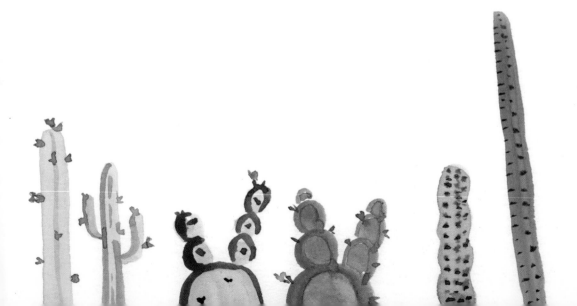

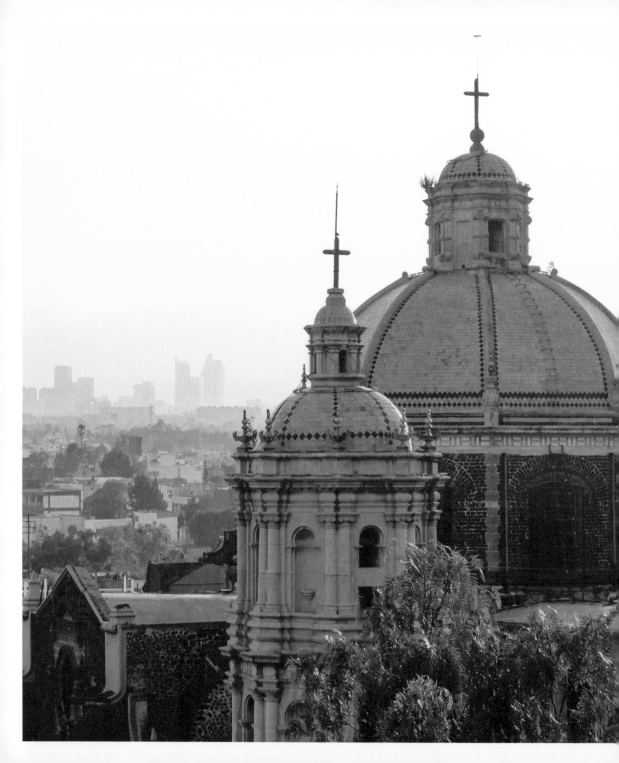

Mexico City, MEXICO

LISTEN TO THE MARIACHI PLAYING IN GARIBALDI SQUARE AT night and visit Frida Kahlo's Casa Azul and the Palacio de Bella Artes. One of Mexico's many highlights is the festival of Día de los Muertos—the Day of the Dead, a raucous and colorful party where people dress in skeletal masks, eat tamales, and listen to songs celebrating the dead with both joy and sorrow. You will want to come back for another visit very soon!

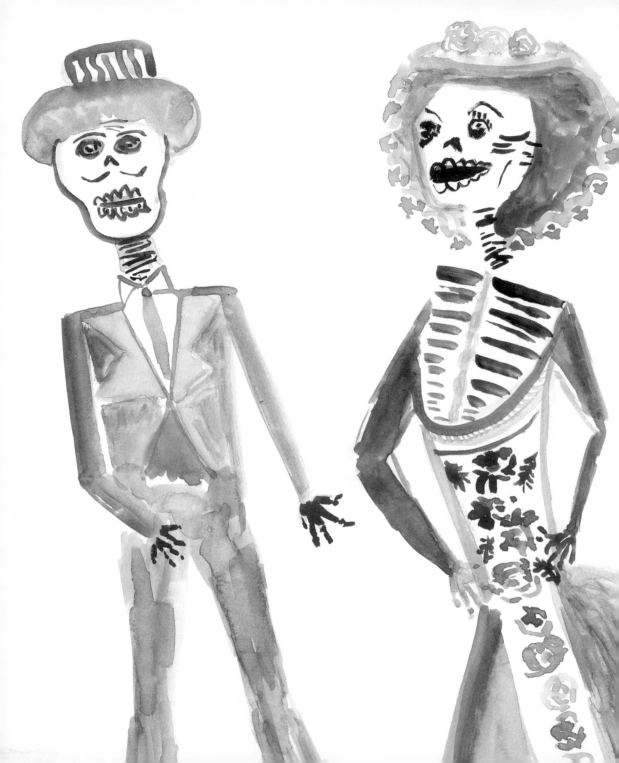

Design your own Day of the Dead mask.

Horchata

A deliciously refreshing drink on a hot day, no wonder horchata is so popular in Mexico! Try it yourself with some amazing tacos from a taqueria.

Makes 6 cups

1 cup long-grain white rice

1 cinnamon stick

¹/₂ cup chopped almonds

6 cups water

¹/₂ teaspoon of vanilla

¹/₄ cup sweetened condensed milk

1 tablespoon agave (optional)

1 cup almond milk (optional)

Ice, for serving

Ground cinnamon, for garnish

Soak the rice, cinnamon stick (broken into small pieces), and almonds in a bowl with five cups of the hot water for at least 3 hours, or overnight.

Using a blender, blend until the grains of rice are fully ground and smooth.

Strain in a pitcher using a fine mesh strainer.

Add the vanilla and condensed milk and one cup of water.

If you would like it sweeter, you can add a table spoon of agave. If you would like it creamier, add a cup of almond milk instead of a cup of water. Serve in glasses filled with ice and sprinkle a little cinnamon on top.

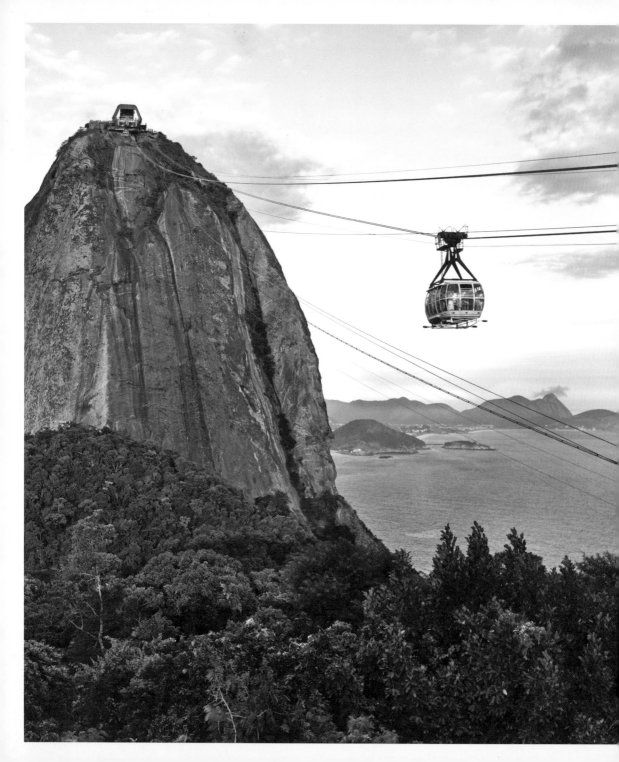

Rio de Janeiro, BRAZIL

GOING TO THE BEACH IS PART OF EVERYDAY LIFE HERE—TO PLAY beach tennis in the sun, surf, or simply people-watch. Copacabana and Ipanema are the most famous beaches; even their names are musical. The mellow Brazilian music called the bossa nova turned the percussive rhythms of carnival songs into a quieter, cooler, guitar-driven style. You can hear its sultry rhythms popping up from the guitar riffs of local street performers to the drumbeats of psychedelic rock bands like the Doors. Listen in and close your eyes. There's nothing like it to help you relax and draw your dreams!

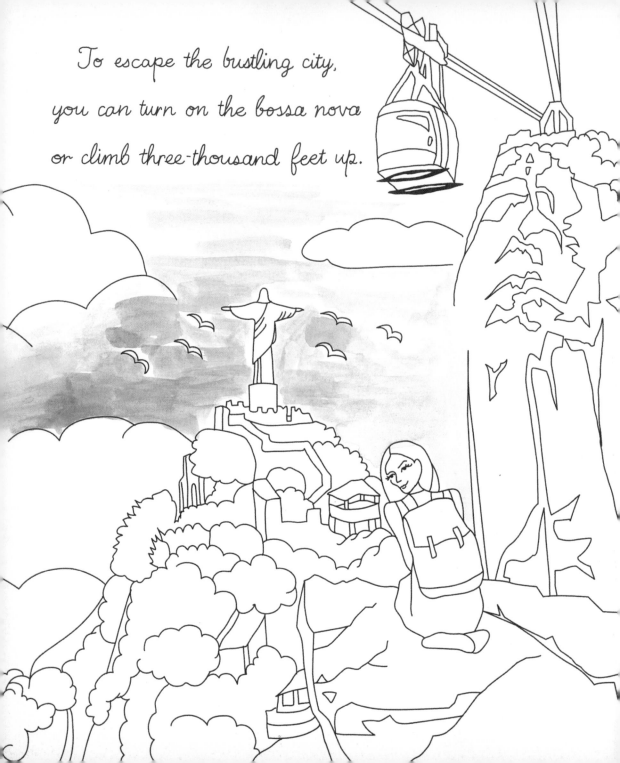

To escape the bustling city,
you can turn on the bossa nova
or climb three-thousand feet up.

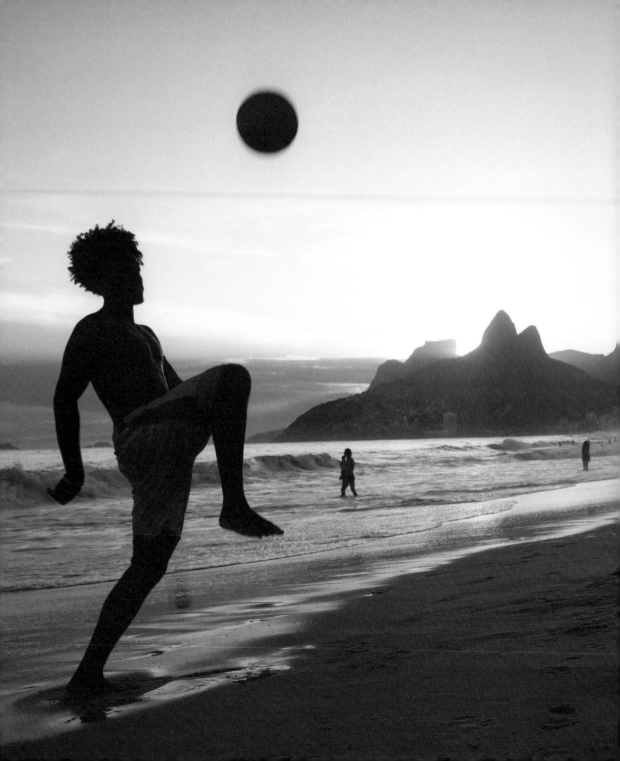

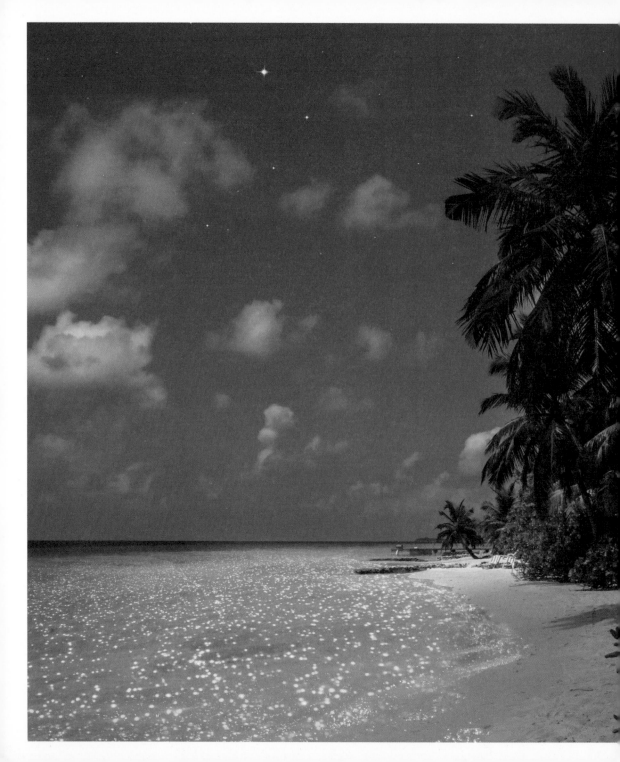

THE MALDIVES

ARE THEY A DREAM? A MIRAGE? NO, THESE ISLANDS ARE REAL!
The underwater world is an endless source of discovery as you dive in to discover schools of colorful fish and coral. These paradise-like islands also make up the world's lowest-lying nation. They are threatened by the rising sea level caused by global warming. The Maldives are as fragile as they are beautiful!

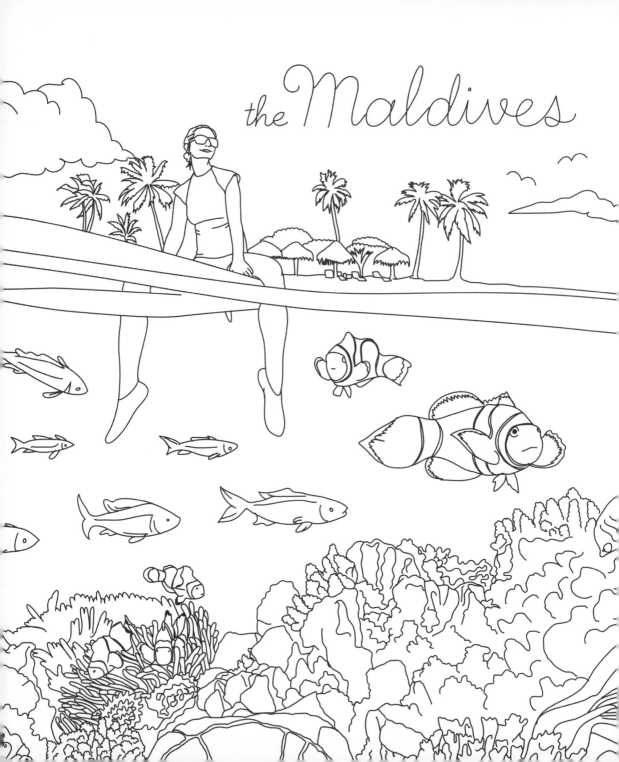

the Maldives

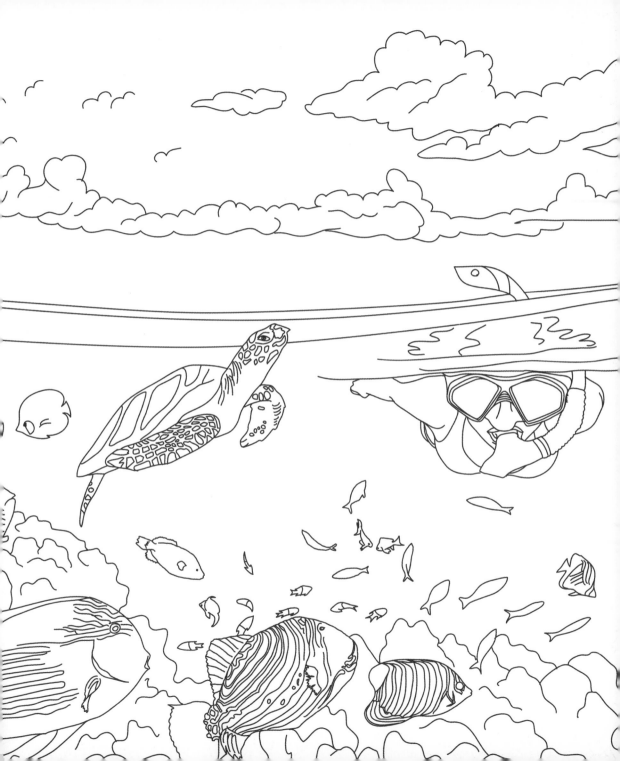

Have you ever tried paddle-boarding?

STAND UPRIGHT ON YOUR BOARD AS YOU ADMIRE THE COLORFUL schools of fish in the water and paddle your way across the bay. It's almost like standing on water! Make sure the wind does not blow you away toward the horizon!

Draw a necklace made of shells!

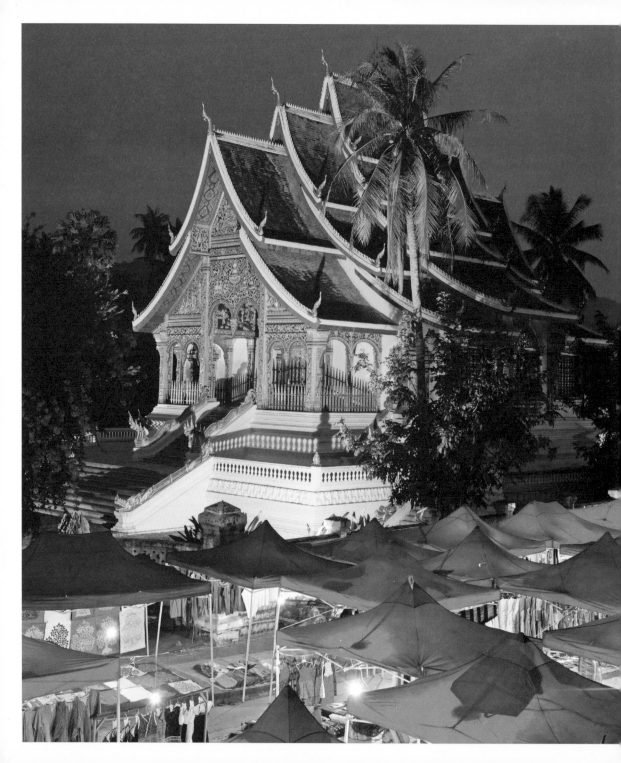

Luang Prabang, LAOS

ADMIRE THE TREE OF LIFE MOSAIC AT THE WAT XIENG THONG MONASTERY.
As you take a walk along the Mekong River, see Buddhist monks clad in orange robes
on their way to the monasteries. Old men sit by the bridge, playing cards, chatting, and
smoking. Farmers harvest their plots. Time seems suspended. The city really comes
to life at night, when the night market takes place with food stalls and craft stands
displaying beautiful carved puppets. A slow and peaceful boat ride up the river will
take you to Pak Ou, caves on the flank of the mountain filled with hundreds of small
Buddha sculptures.

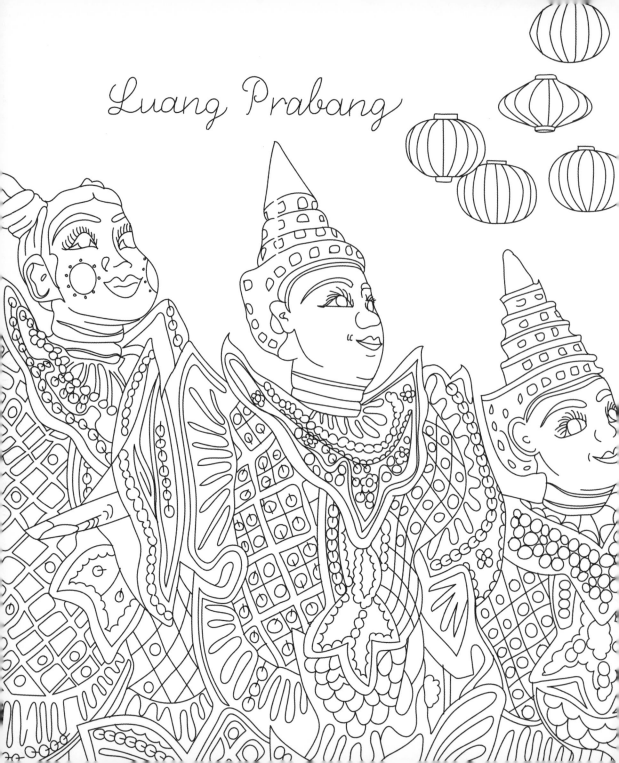

Luang Prabang

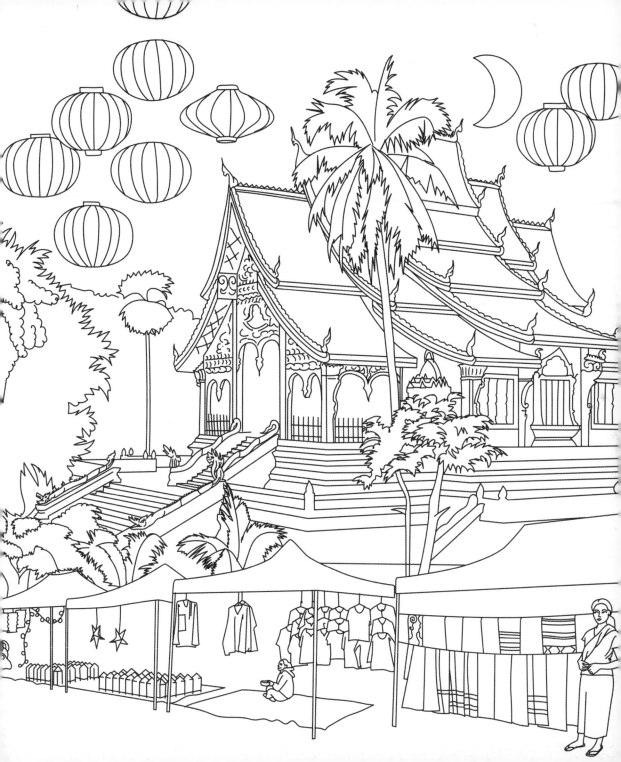

Have you ever practiced
Zen meditation?
You can do it anywhere,
even in a crowded subway!

TRY IT AT HOME, EARLY IN THE MORNING.
Put a pillow on the floor; it will be slightly more comfortable;
sit cross-legged, your hands resting on your knees. Try sitting
still for ten minutes the first time. Close your eyes. Inhale. Exhale.
Let your mind guide you. Try not to move. Just focus on your
breath. Soon you will be able to stand still for twenty minutes,
even thirty minutes. Buddhist monks can meditate for
hours on end so you can do it for just a little while!

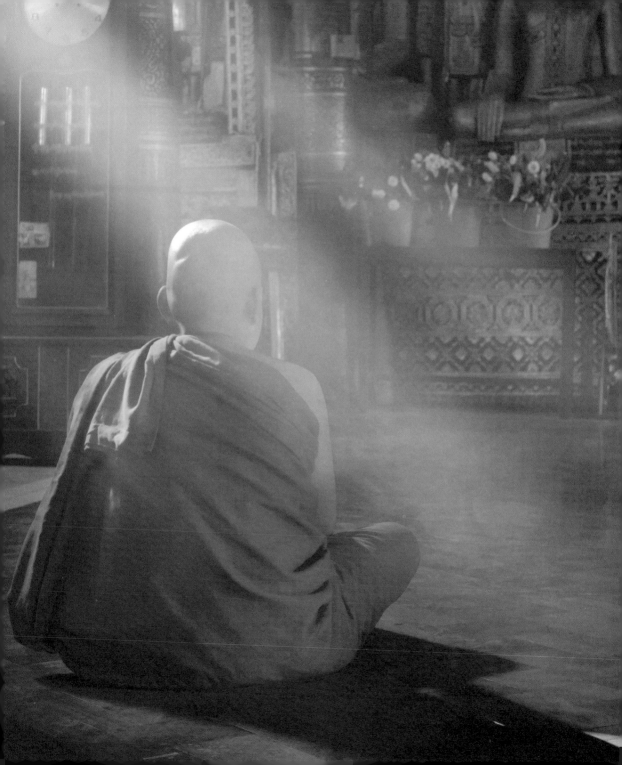

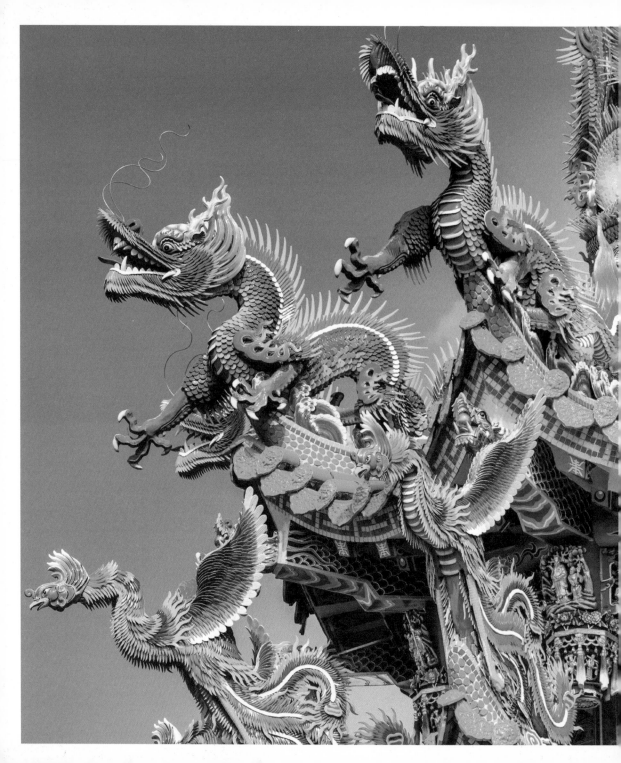

Taipei, TAIWAN

IF YOU LIKE STREET FOOD, THEN TAIPEI IS THE PLACE FOR YOU!
Stroll around to find *baos* (steamed bun sandwiches), dumplings filled with hot broth, braised pork rice, beef noodle soup, and bubble tea. After a meal of such delicious comfort food, light a paper lantern and let it float in the night to carry your wishes to the moon and stars. During the Lantern Festival on the fifteenth night of the first month in the lunar year, an array of dazzling lanterns are lit at the same time and float to the sky, making the whole city glow. What would you wish for? Who would you send your lantern off into the sky with?

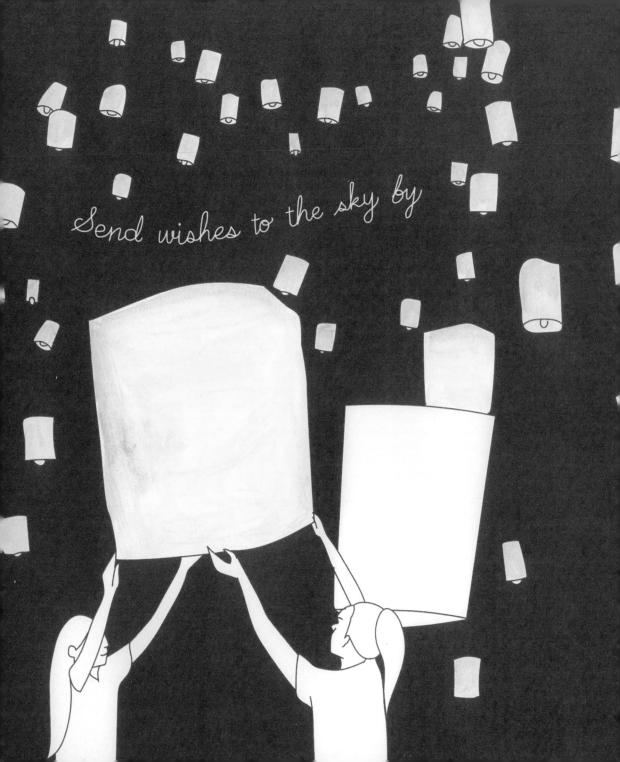

lighting sky lanterns in Taiwan

Imagine all the street food and goods
you would find at the local market.
What would you go in search of in Taipei?

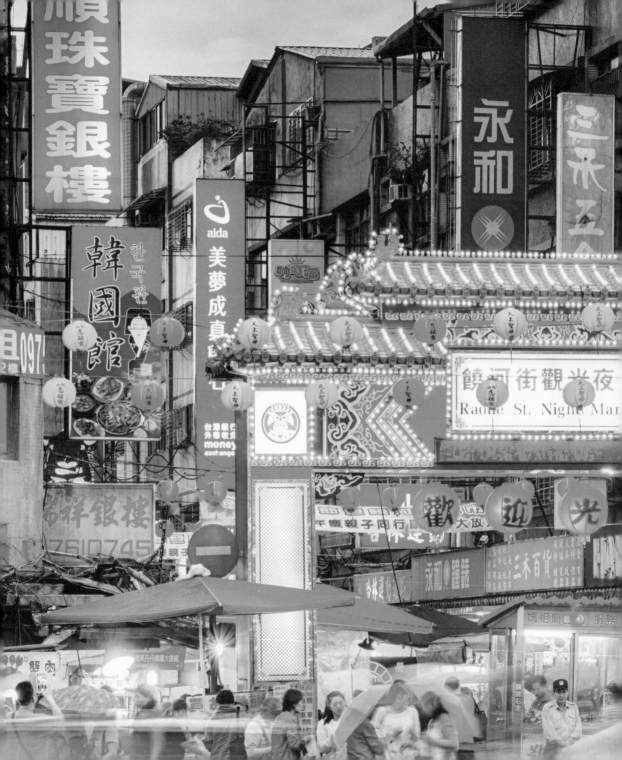

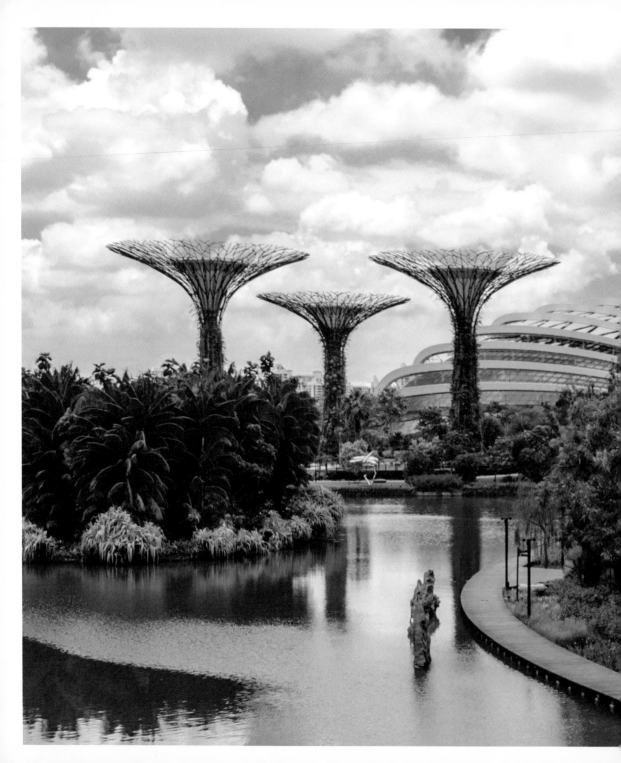

Gardens by the Bay, SINGAPORE

THIS FUTURISTIC URBAN GARDEN INCLUDES SEVERAL TREELIKE VERtical gardens and is an extraordinary architectural landmark. One conservatory recreates the Mediterranean climate while the second one, a cloud forest, replicates the climate found in tropical mountain regions. The supertrees are a concrete structure with metallic branches, covered with flowering plants. The lush garden is made of a myriad of tropical plants and thousands of different orchid types, creating a much welcome ecosystem in the heart of the city. Climb to the top of the supertrees, which are eighty-two feet high, and you will simply be mesmerized by the view!

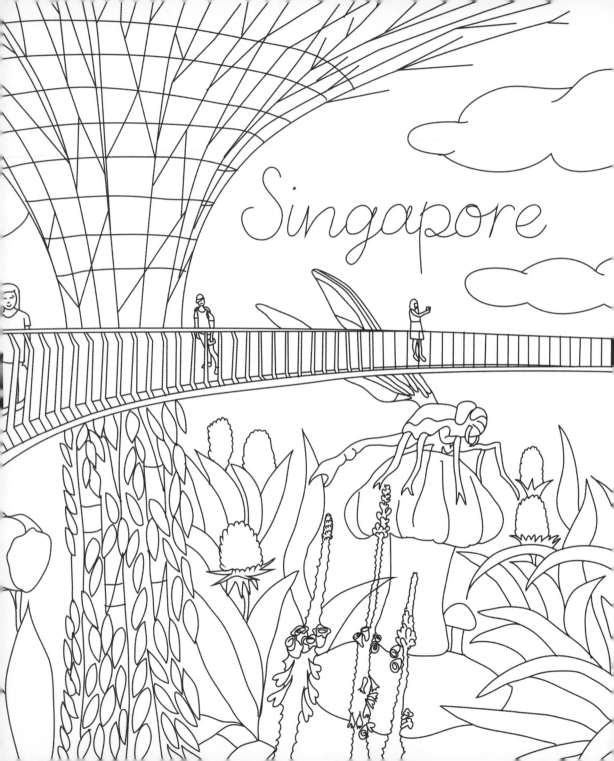

London, ENGLAND

BIG BEN, THE TOWER OF LONDON, THE THAMES, THE LONDON EYE . . . the many landmarks of London retrace its history. When spring comes, fields of white and yellow daffodils cover the parks of London, like St. James's Park, near Buckingham Palace. In June, you can watch the Horse Guards Parade for the Queen's birthday. Go to the British Museum and discover the most beautiful historical objects from around the world: the Rosetta Stone, gold jewels from ancient Egypt, a mechanical celestial globe from the German Renaissance, and many other treasures. In Camden, you'll stumble upon vintage stores and a flea market. You can always take a break in a neighborhood café and enjoy a strong cup of tea to warm you up on a rainy day.

Who is your favorite Shakespearean character?
Can you draw their costume here?

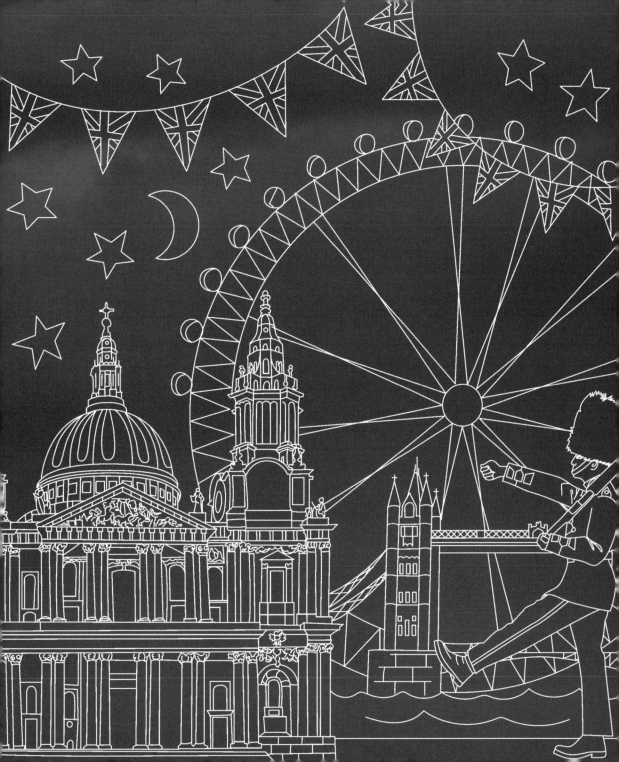

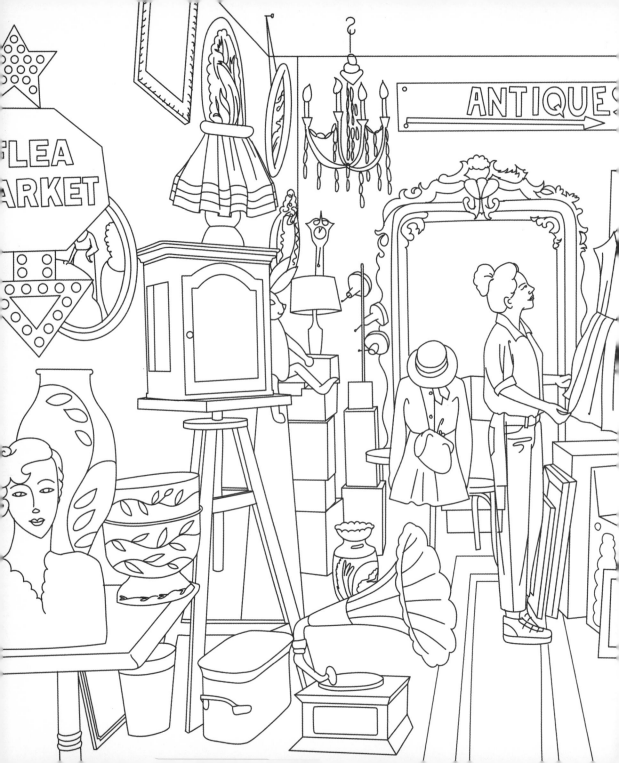

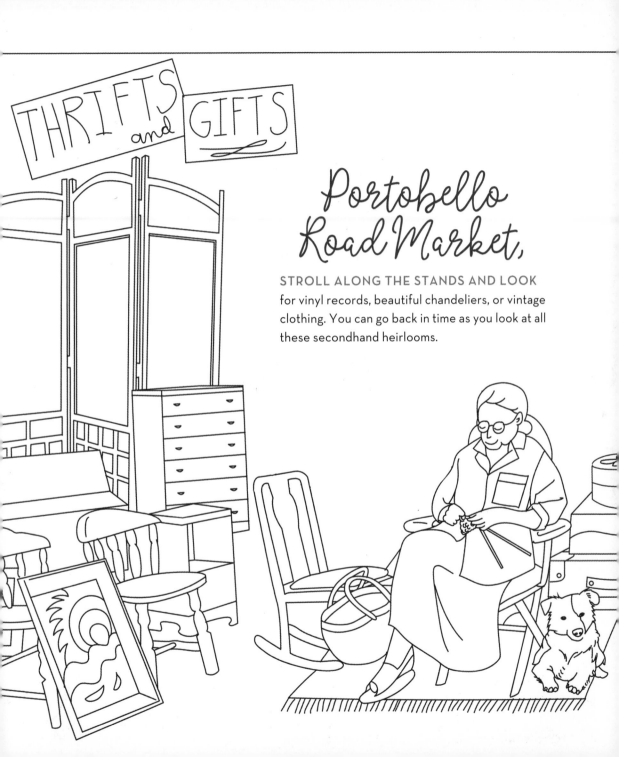

Portobello Road Market,

STROLL ALONG THE STANDS AND LOOK for vinyl records, beautiful chandeliers, or vintage clothing. You can go back in time as you look at all these secondhand heirlooms.

SWEDEN

BEAUTIFUL AND PRACTICAL IS THE ETHOS OF SWEDISH DESIGN.
You will love the design stores filled with elegant and useful objects that will make your house even cozier. Winter in Sweden is bleak and long, but the Swedes know how to turn these dark winter days into something pleasant. *Hygge* (pronounced hooga) means coziness and togetherness: lighting candles at home, snuggling in a blanket with a hot tea or glass of wine, and chatting with friends. And when the summer comes, the country turns into heaven on earth! Think of summer in the countryside—picking wild strawberries, taking long naps in the grass, admiring clouds drifting in the sky, or picnicking by the sea. Sweden has it all!

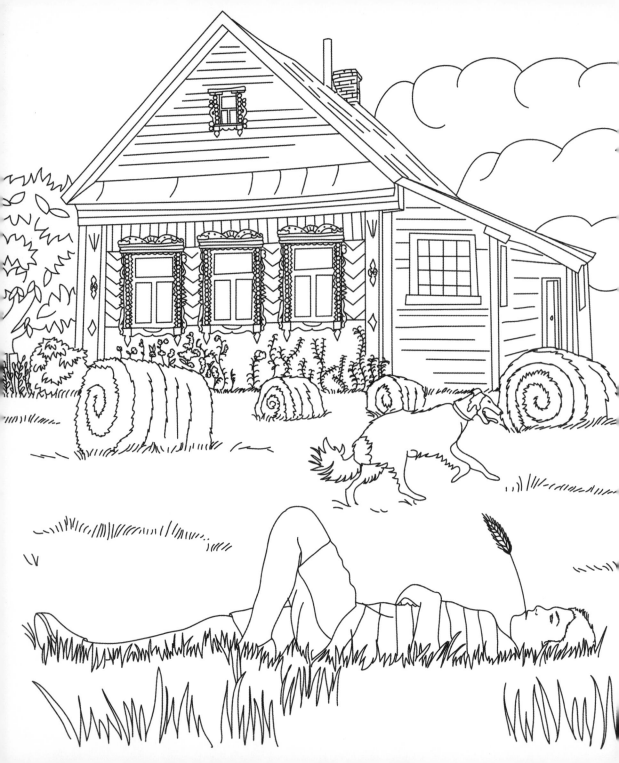

This summer, make your own
herbarium by pressing leaves and flowers
in a book. Arrange them by size
and shapes to create a pattern.

Make your own Strawberry Jam!

**This recipe makes about two jars. Ideally, pick your
own strawberries, or buy them at your local farmers' market.**

**3 pints wild strawberries,
washed and halved**

3 cups sugar

1 teaspoon lemon juice

In a large bowl, mix the fruit and the sugar, then add
the lemon juice. Let it sit for 30 minutes. Transfer the
mixture to a large pan and place on the stove over
medium heat. When the mixture starts boiling, lower
the heat to a simmer. Let it cook for an hour and a
half, stirring occasionally. Skim off any foam. When
the liquid has evaporated and the jam is thick, ladle
the jam into clean jars and refrigerate.

Tomorrow you can bake fresh scones and serve
them with your homemade jam!

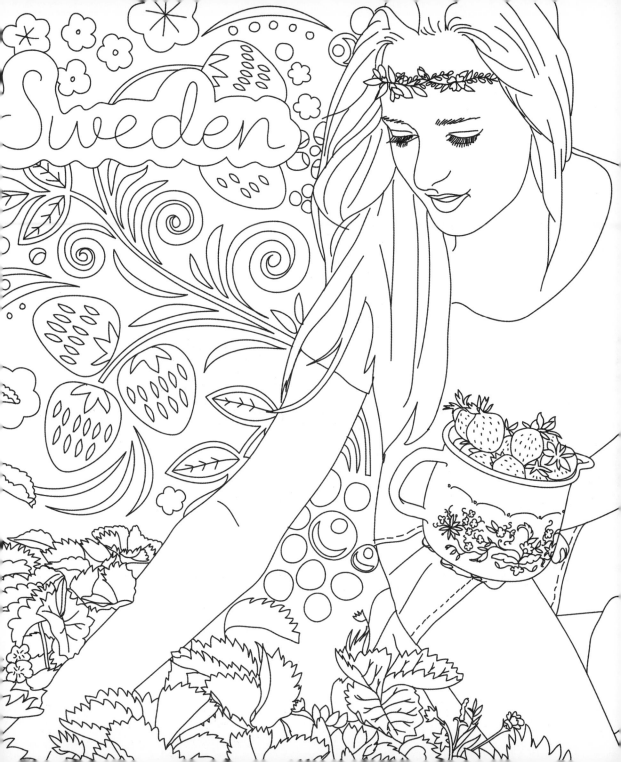

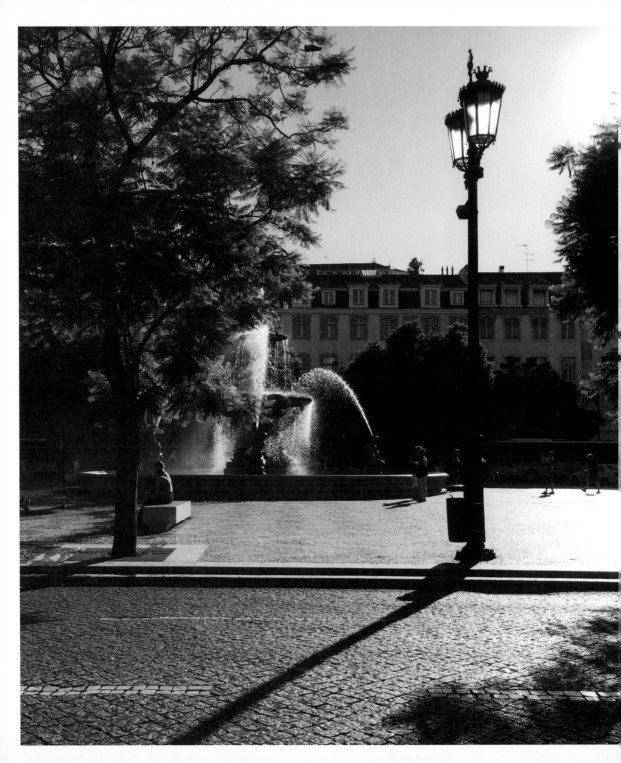

Lisbon, PORTUGAL

AS YOU EXPLORE LISBON, LOOK CLOSELY AT THE BUILDINGS. THEY will tell you the story of the city. Azulejos are beautiful tiles that adorn the facades of houses; usually white and blue. They depict rural scenes: villagers harvesting wheat, an ox pulling a cart, or religious icons like the Virgin Mary. They can also be ornate, with gorgeous flower patterns. At night, soulful fado music will bring joy and sorrow to your heart as you fall in love with the city.

The tower of Belém on the Tagus River
looks straight out of a fairy tale. How would
you describe it in a postcard to a friend?

PLACE
STAMP
HERE

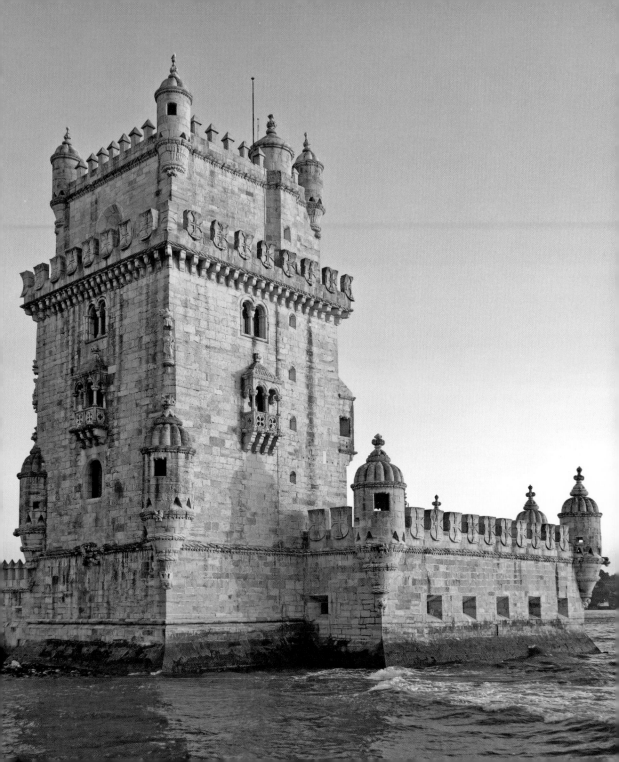

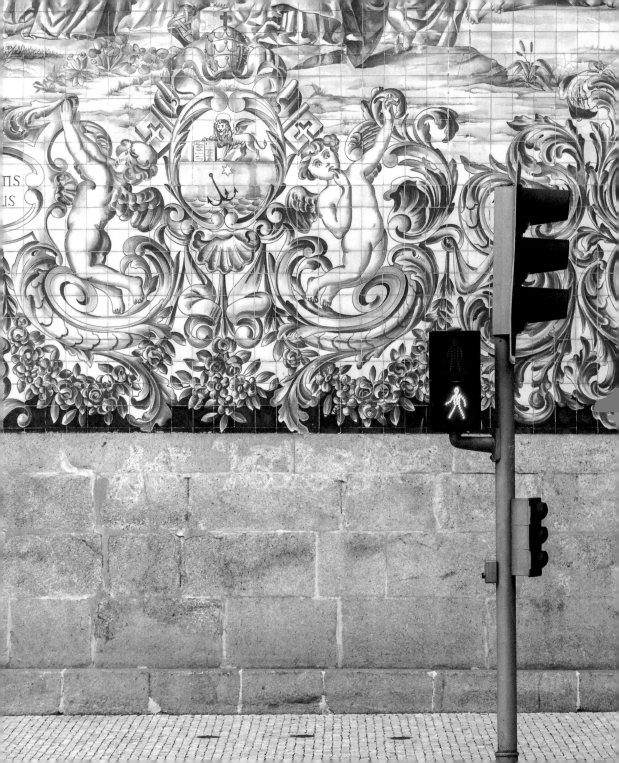

See these azulejos (ceramic tiles)? In Lisbon
they are generally blue and white, but feel free
to color these any shade of the rainbow!

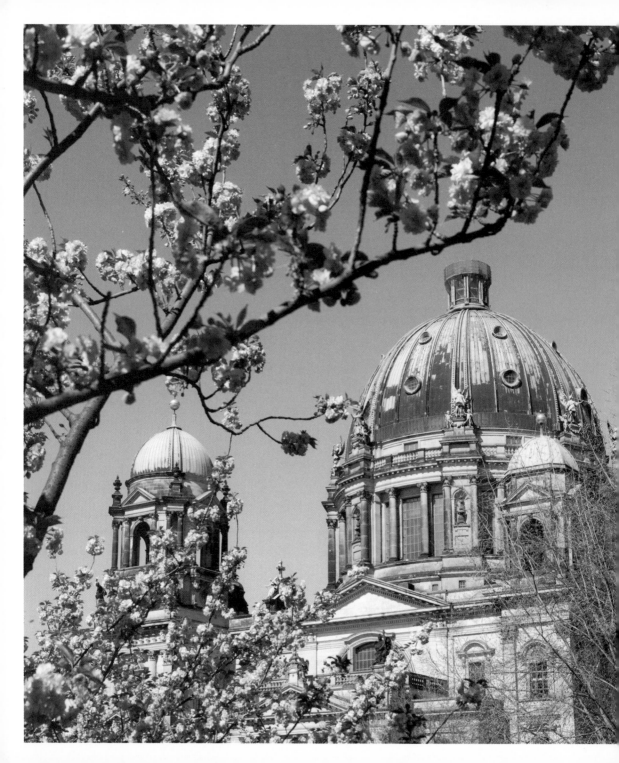

Berlin,
GERMANY

IF YOU WANT TO LEARN ABOUT EUROPEAN HISTORY, GO TO BERLIN!
There you will discover artifacts from Greece at the Pergamon Museum and learn
about the origins of democracy. As you stroll down the streets, you can spot the
remainders of the Berlin Wall. The tall Brandenburg Gate has become a symbol of
German reunification. Enjoy a slice of apple strudel at Einstein Café, or visit the
Gemäldegalerie and the Jewish Museum.

What do you prefer?
Listening to a classical concert
at the Berlin Philharmonic
or dancing the night away to
the beats of electronic music?
You may like both! If so,
here is some music you may enjoy

- Robert Schumann, *Symphonies*, conducted by Simon Rattle
- Gustav Mahler, *Sixth Symphony*, conducted by Claudio Abbado
- Spins by a great DJ such as Ben Klock or André Galluzzi
- The beats of Tonkind

Can you imagine a city divided by a wall?
What would that be like?

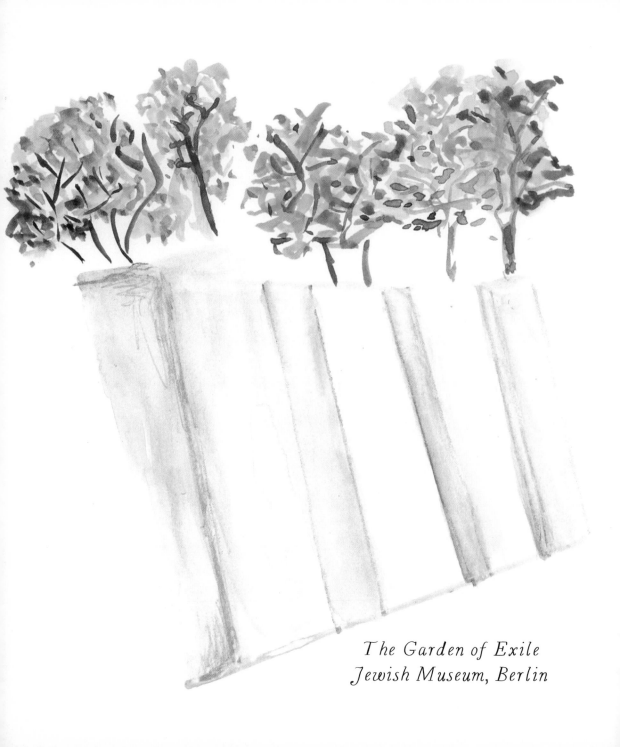

The Garden of Exile
Jewish Museum, Berlin

Pack a picnic and watch the world
go by in one of Berlin's famous parks.

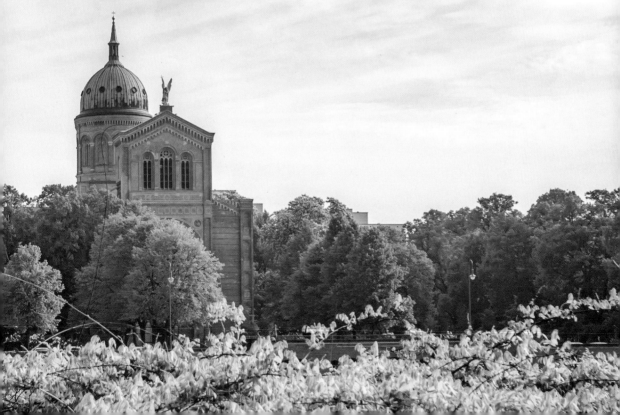

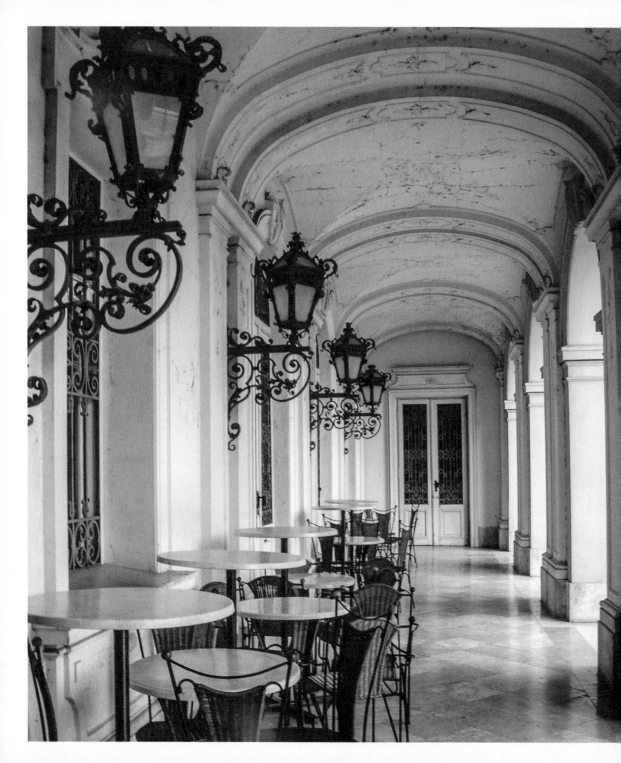

Vienna,
AUSTRIA

IN THE BEGINNING OF THE TWENTIETH CENTURY, VIENNA WAS AN intellectual and artistic capital. Artists and writers would meet in the celebrated coffeehouses. There are so many great works of art to see in Vienna, including Arcimboldo's fruit faces, Klimt's mosaiclike paintings, and Egon Schiele's tortured self-portraits.

Look around town at the facades of buildings decorated in the Secession style and enjoy a slice of the classic Viennese cake, the deeply chocolatey *Sachertorte*, served with a side of whipped cream. The recipe has not changed since 1832!

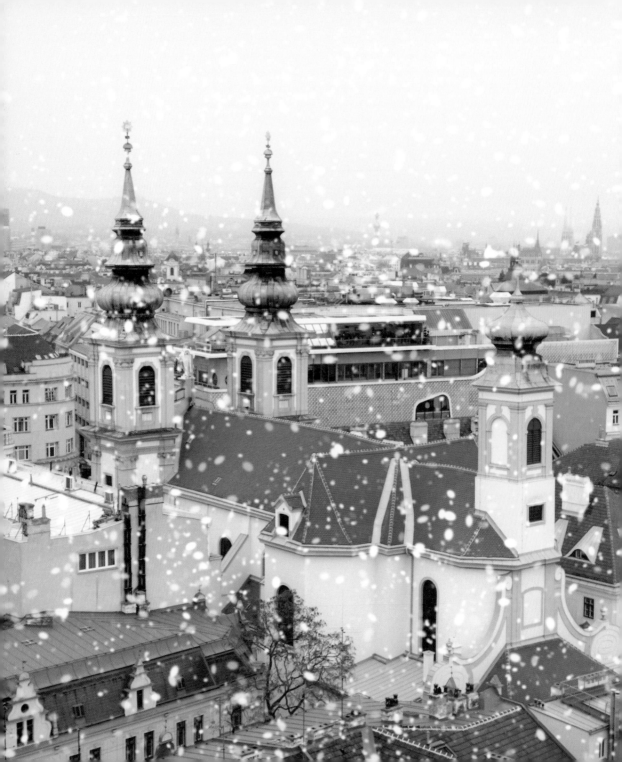

Vanillekipferl (Almond Crescent Cookies)

This traditional Austrian recipe is a treat for all come the end of the year, when it is cold and snowing. It's best enjoyed with a cup of hot chocolate!

Makes 32 cookies

14 tablespoons butter (at room temperature)

Pinch of salt

2 tablespoons vanilla sugar

1 egg yolk

2 cups flour

¾ cup ground almonds

2 tablespoons icing sugar, to dust the cookies

In a large bowl, mix the butter, salt, vanilla sugar, and egg yolk. Add the flour and ground almonds. Knead the dough. Let it rest for two hours.

Preheat the oven to 320°F. Roll 1 tablespoon of the dough into a little crescent shape. Repeat until all of the dough is used. Put the cookies on a greased baking sheet, or a sheet lined with parchment paper. Bake for 12 to 15 minutes until the cookies are golden. Remove the almond crescents carefully. Dust with icing sugar while warm.

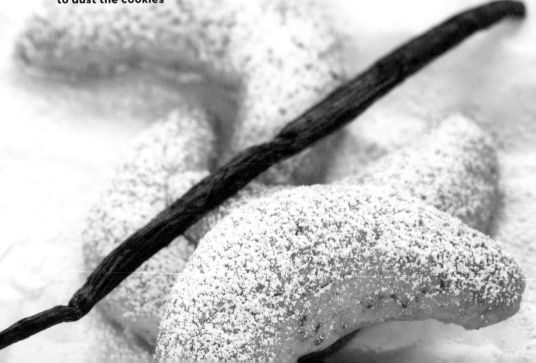

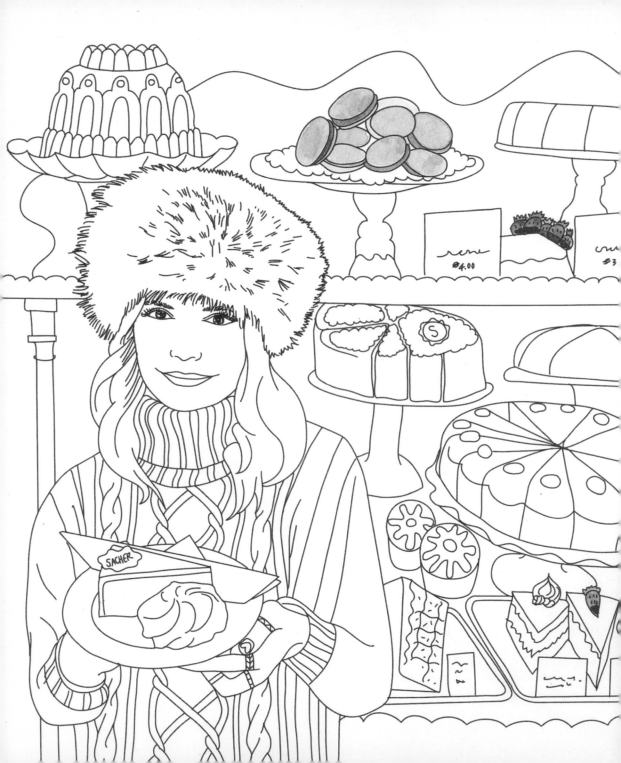

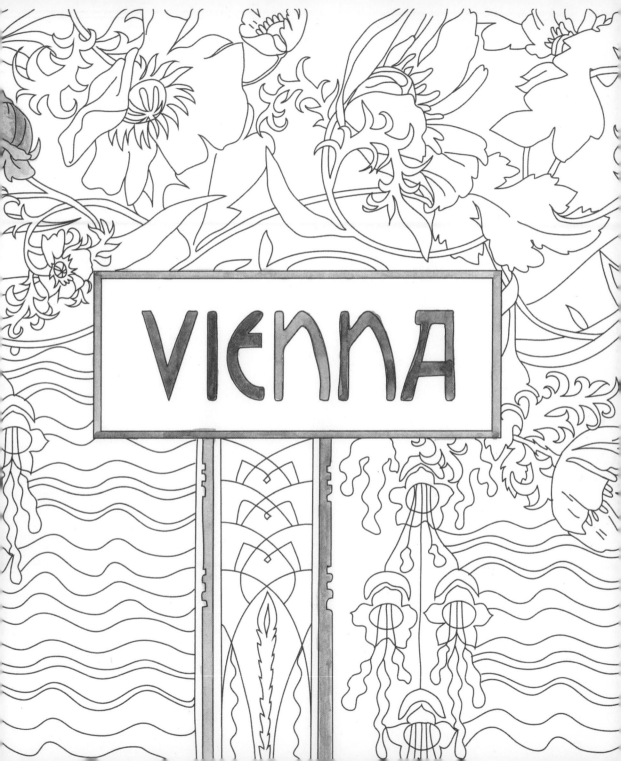

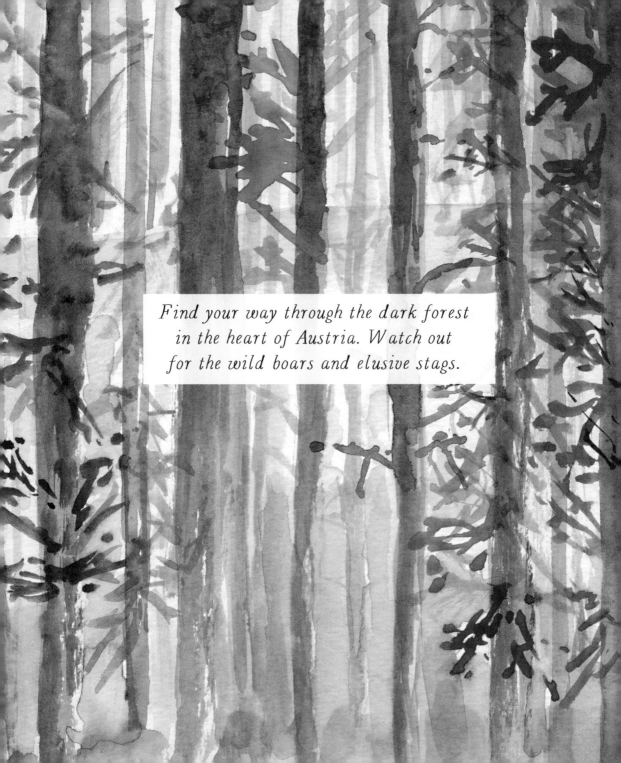

Find your way through the dark forest
in the heart of Austria. Watch out
for the wild boars and elusive stags.

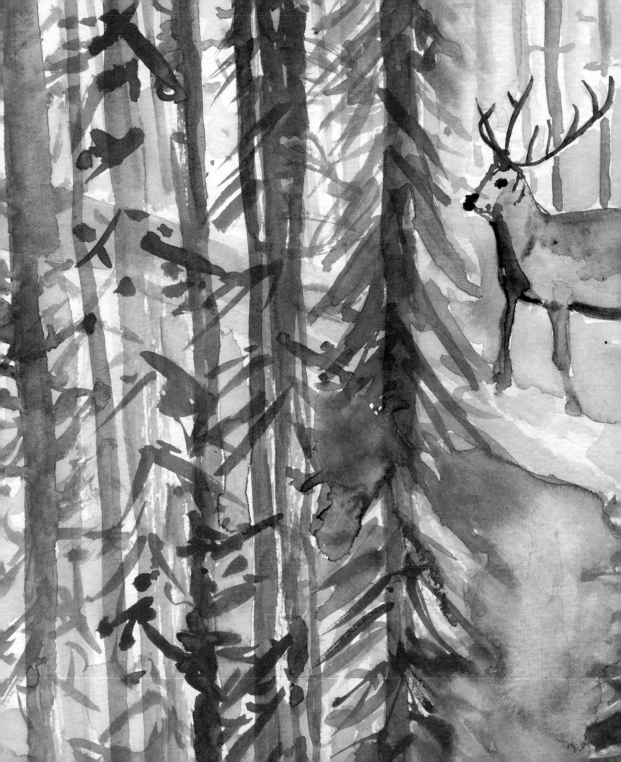

JAPAN

WALK ALONG THE STREETS OF TOKYO TAKING IT ALL IN: THE NEON colors, the eclectic street style, the confounding street signs. Aboard the bullet train, nothing is out of reach. And the cure to that frenetic pace is harmony!

Outside of the busy cities, sit in an outdoor wooden hot tub, an *onsen*, and look up to the sky and stars and the snow surrounding you. This is the most relaxing place on earth! Then put on a fresh cotton kimono and get ready to enjoy a *kaiseki*, a long and delicious meal.

In Kyoto, visit temples and take part
in a tea ceremony with a tea master.

ADMIRE THE CERAMIC CUP IN WHICH THE MATCHA TEA IS served and the lacquered plate on which a red-bean cake shaped like a cherry blossom rests for you to take a bite to balance the bitterness of the tea.

In a tea house you may meet a *maiko*, an apprentice geisha. There she is standing in front of you, her face painted white, her lips red, her black hair tied. There is so much going on in this moment. Years were devoted to the study of the tea ceremony and the arts of dancing and playing the *shamisen*, a three-stringed traditional instrument. And all of it makes this instant richer. You will always remember it. As you will remember the shapes of the pebbles in the zen garden imitating the movement of a wave, or a simple branch of peach tree blossoms in a narrow earthenware vase.

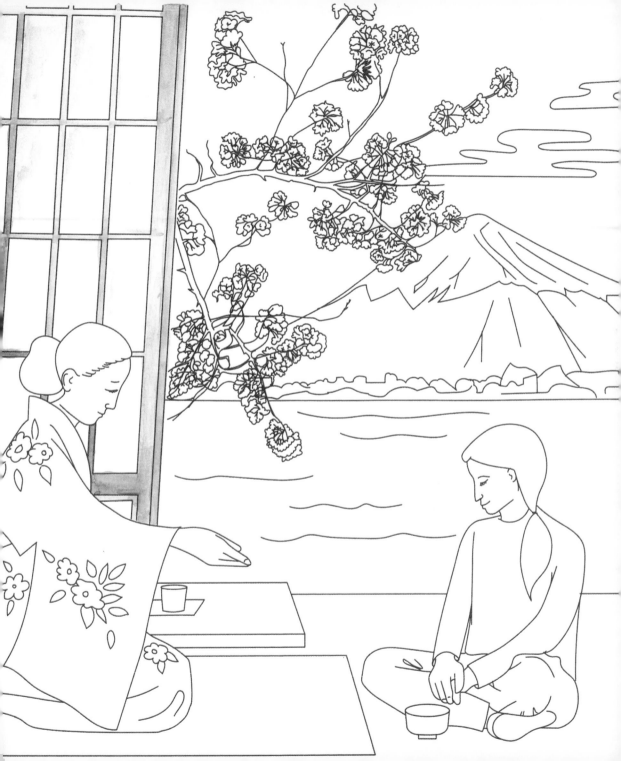

Another meditative and highly focused activity is free-diving. Can you imagine diving deep into the sea without an air tank?

IT'S A TWO-THOUSAND-YEAR-OLD TRADITION IN SOME PARTS OF Japan. Mostly women, but some men as well, hold their breath while diving in the ocean, fishing for pearls—they are called *ama*, or "sea woman."

Would you dive in with them? What would you find at the bottom of the sea?

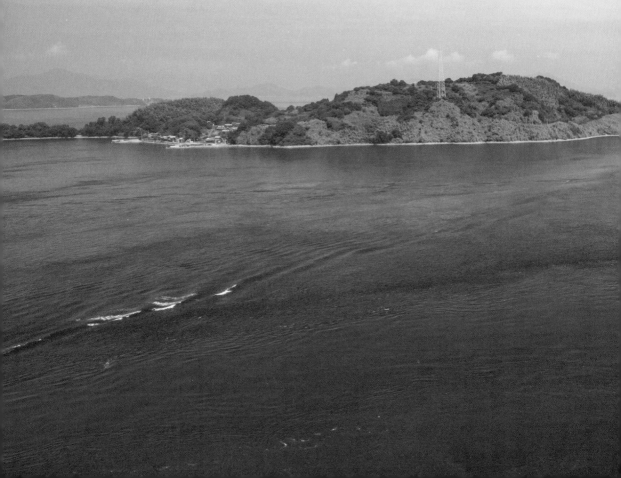

The Inland Sea, stretching between
Honshu, Kyushu, and Shikoku,
fills the mind with blues—the azure of
the sky, the indigo of the sea, and the slate
blue of the islands seen in the distance.

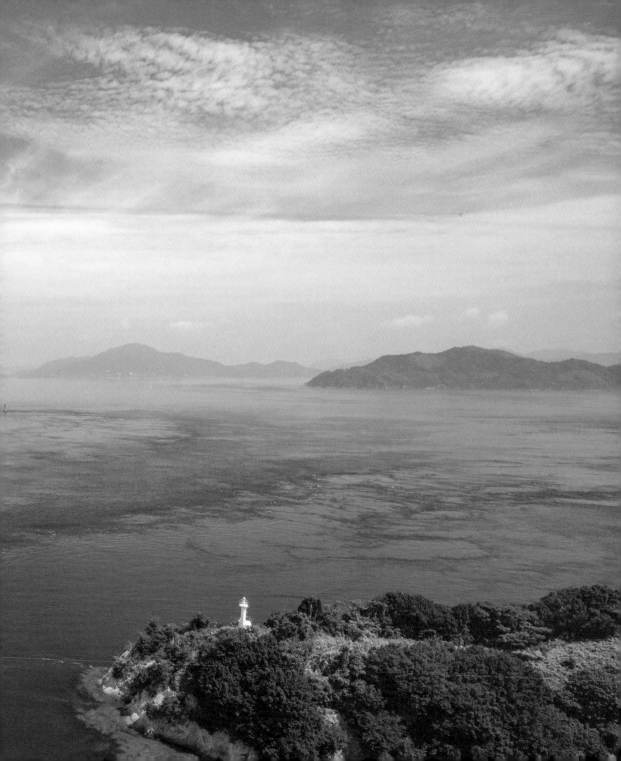

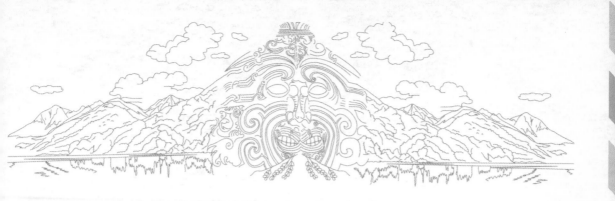

NEW ZEALAND

EPIC LANDSCAPES, FORESTS, AND FJORDS ABOUND IN NEW ZEALAND.
Go canoeing in Mine Bay in Lake Taupo and admire up close the rocks carved with Maori legends created in the 1970s by master carver Matahi Whakataka-Brightwell. They depict Ngatoroirangi, a Maori navigator who guided the Tuwharetoa and Te Arawa tribes to the Taupo area more than a thousand years ago. And to celebrate the multicultural influences that define New Zealand today, the artist also depicted elements of Celtic folklore, such as a mermaid and the South wind. And, of course, watch out for hobbits!

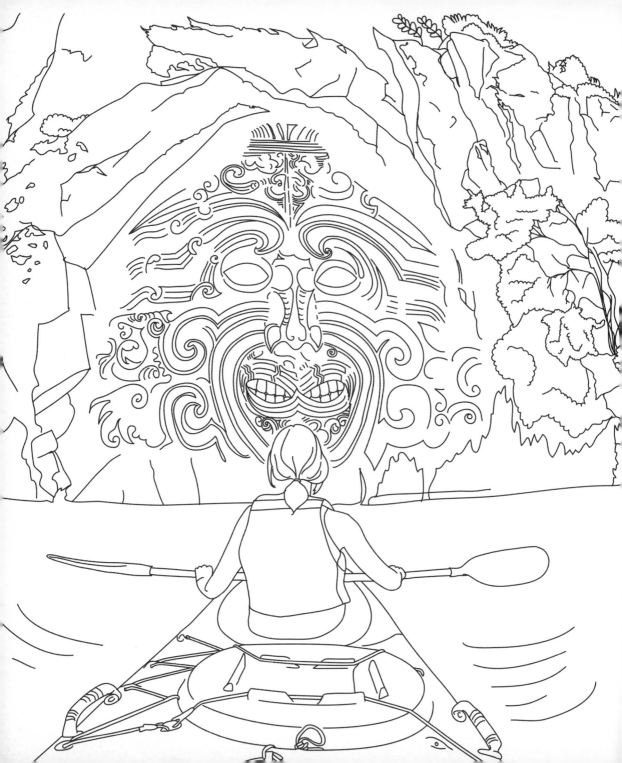

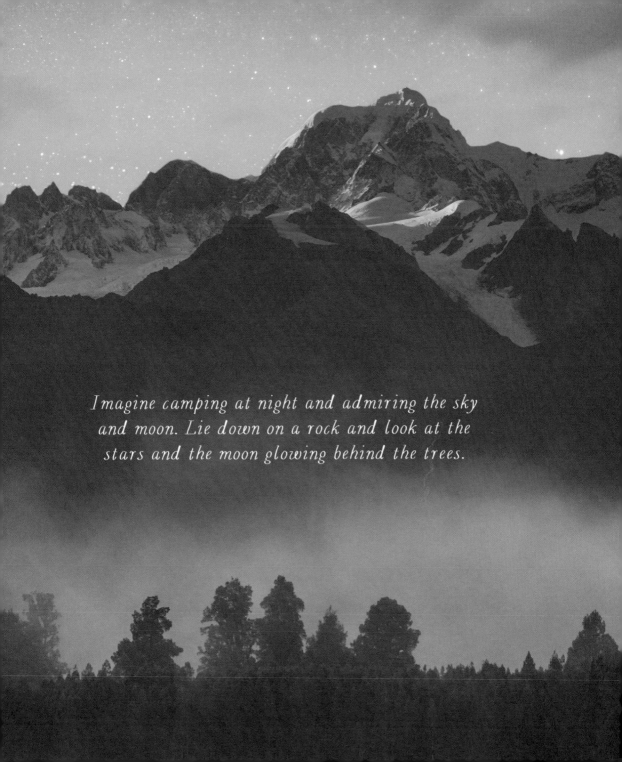

Imagine camping at night and admiring the sky and moon. Lie down on a rock and look at the stars and the moon glowing behind the trees.

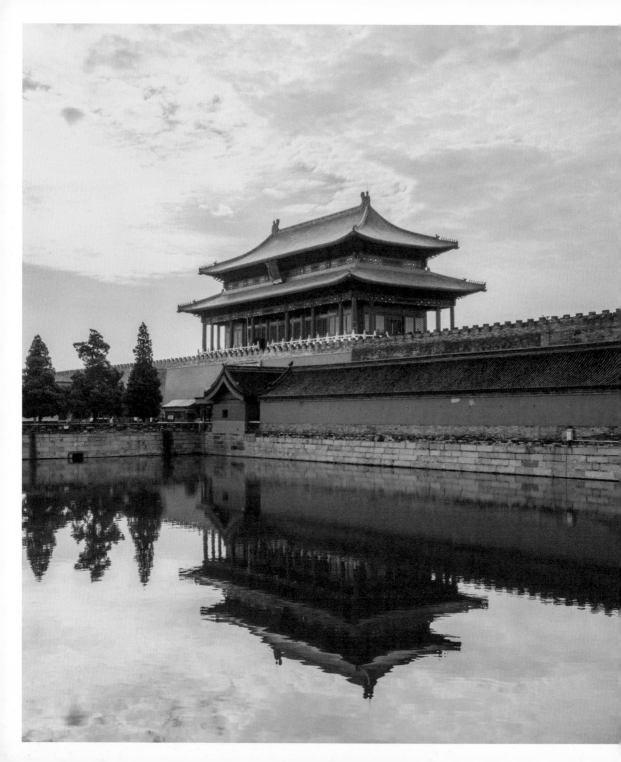

和平愛

Beijing, CHINA

AS HÚTÒNGS (OLD ALLEYWAYS) GRADUALLY GIVE WAY TO HIGH-RISES and the city transforms by the minute, you can seek out peace and quiet in the parks and temples. People escape the frenetic pace of urban life by meditating as they practice Tai Chi or spend a lifetime mastering the art of calligraphy, sometimes by drawing ephemeral symbols with water on asphalt. The pavement turns into a giant piece of paper, and the calligrapher becomes a dancer.

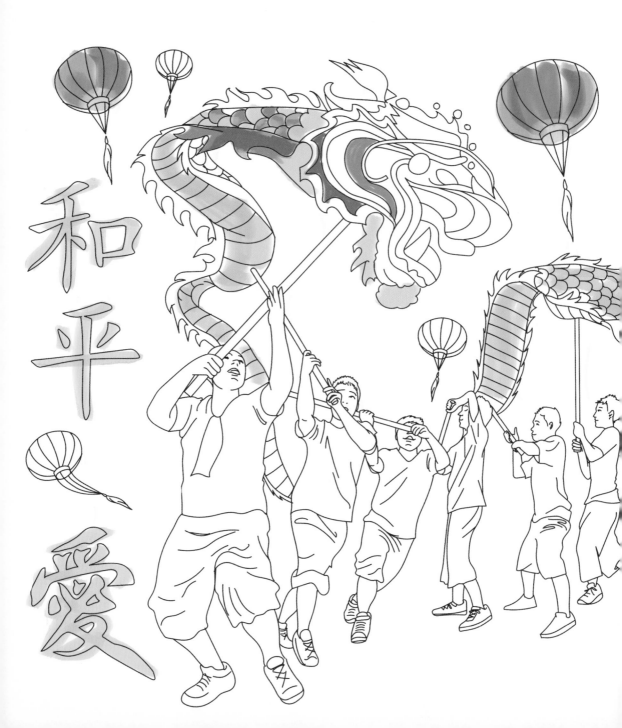

China produces about 70 percent
of the world's mobile phones and 60 percent
of its shoes. Can you design a brand new object
to be manufactured in a Chinese factory?

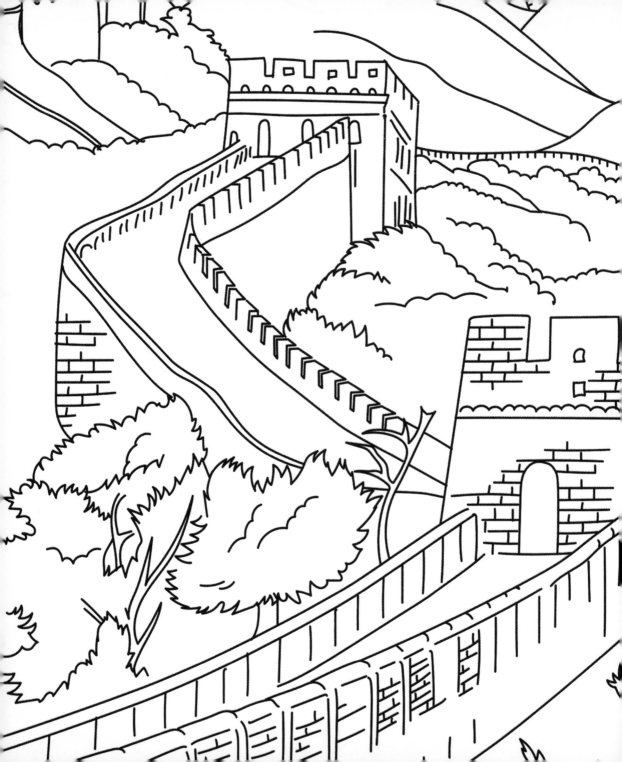

Do you think you can walk to the end of the Great Wall of China? Sure, if you have eighteen months to spare!

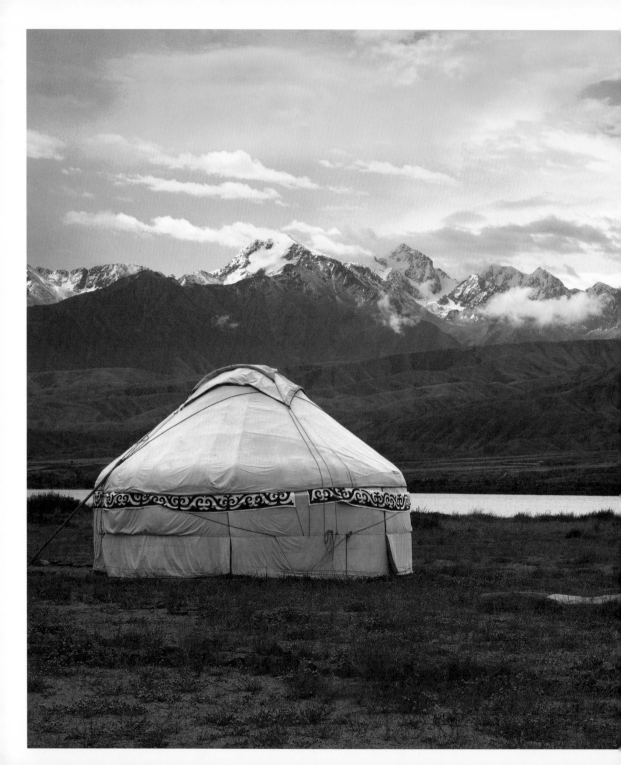

MONGOLIA

FOLLOW THE LEAD OF AN EAGLE HUNTER AS YOU HORSE-RIDE IN THE steppes of Mongolia. These hunters train golden eagles, which have a wingspan of over six feet, to catch prey for them. Mongolian nomads live in *gers*—circular yurts. Their tough and powerful horses can travel more than sixty miles a day. Imagine galloping in the vast Altai Mountains, faster and faster. You too may feel like you have wings.

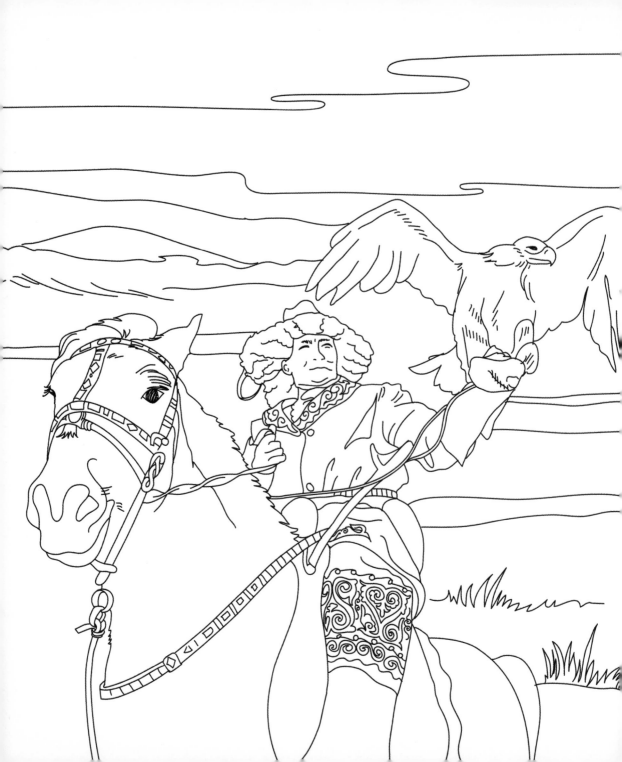

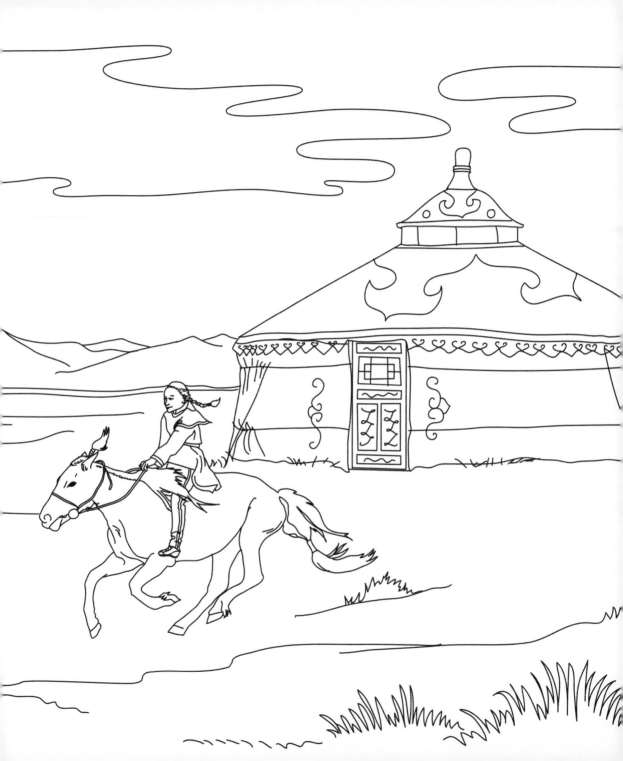

Cairo, EGYPT

THE PYRAMIDS OF EGYPT ARE A SOURCE OF MARVEL. BUILT AS TOMBS for the pharaohs, some are engraved in hieroglyphs describing the life and times of the buried kings of Egypt. They are among the world's most ancient monuments—the oldest, in Saqqara, was built around 2630 BCE! The Great Pyramid of Giza, on the west bank of the Nile, near Cairo, is the largest pyramid in the world. It is one of the seven wonders of the Ancient World and the only one remaining today.

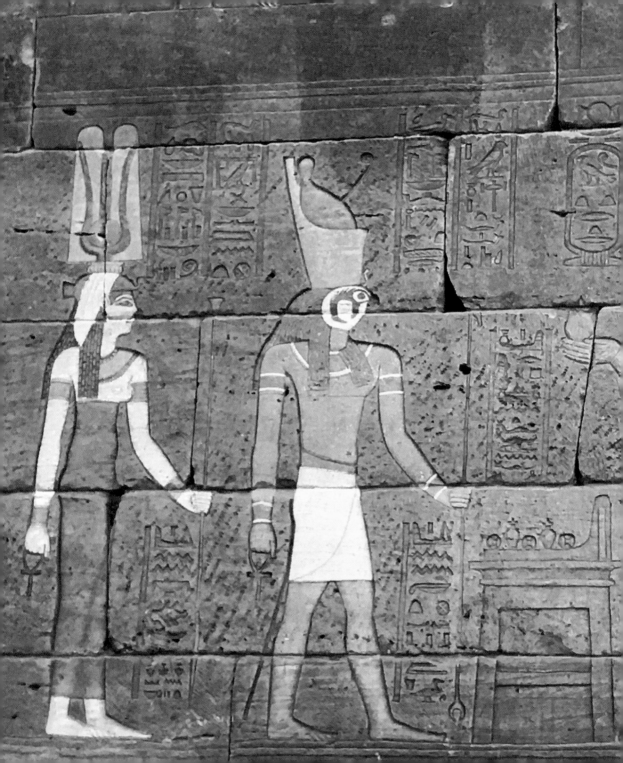

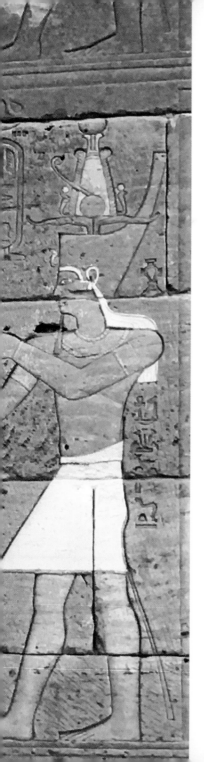

See these colorful hieroglyphs?

TODAY THE WALLS ARE OCHRE OR GRAY AS they have lost their pigments, but they used to be brightly colored. At the Metropolitan Museum of Art in New York City, one can see the Temple of Dendur. Using new technologies, the museum is able to project lights on the stone surface to digitally restore the colors of the temple and let the visitor see how brightly colored the walls once were. This is called projection mapping and is known as spatial augmented reality.

In the scene depicted here, the pharaoh is offering wine to two deities: Hathor and Horus. The goddess Hathor is recognizable by her headdress of horns. She was the goddess of love and joy. Horus, most often depicted as a falcon, was the husband of Hathor and was the god of the sky. As a tutelary deity, he was a symbol of kingship and considered to rule over the entire kingdom of Egypt.

155

Draw your own hieroglyphs here.

Marrakesh, MOROCCO

ALL YOUR SENSES COME ALIVE IN THE MEDINA, THE OLD CITY, WHERE lies the square of Djemaa El-Fna, which is always full of activity. Hear the orange-juice vendors, the water sellers in large, fringed hats, and the peddlers calling out to sell their wares. A coiled snake bobs its head to the music of a flute. See the colorful carpets and ceramic bowls at the soukh. Taste a plate of golden couscous with fragrant vegetables, dried fruits, and spices. Touch a piece of supple leather. Which colored babouche slipper will you pick?

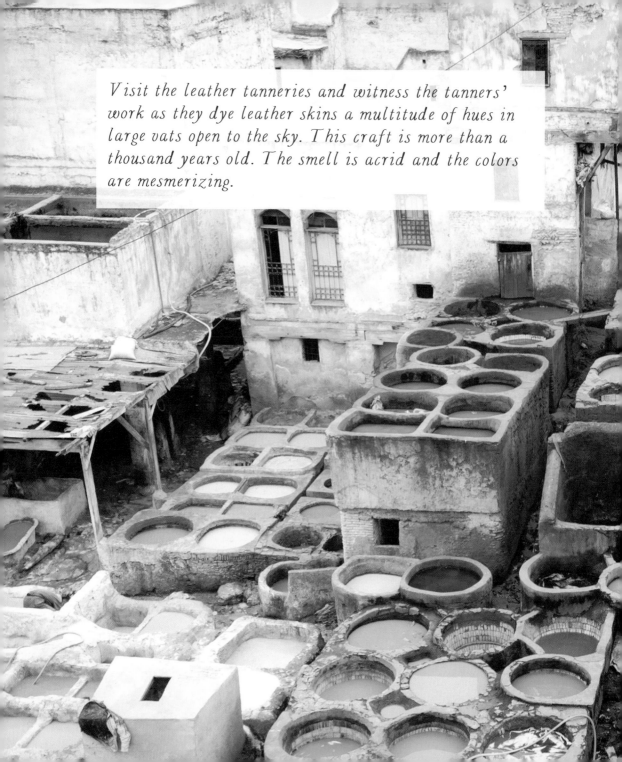

Visit the leather tanneries and witness the tanners' work as they dye leather skins a multitude of hues in large vats open to the sky. This craft is more than a thousand years old. The smell is acrid and the colors are mesmerizing.

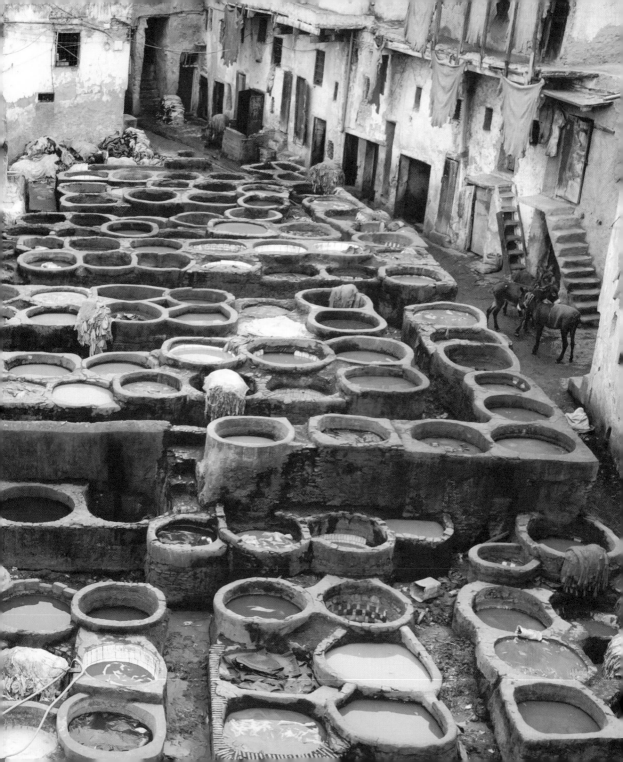

Yves Saint Laurent
and his partner created the
most wonderful house in the heart
of Marrakesh, called the Jardin
Majorelle. The garden is an oasis
vibrant with Matisse's colors,
with ceramic pots painted
red, yellow, and blue.

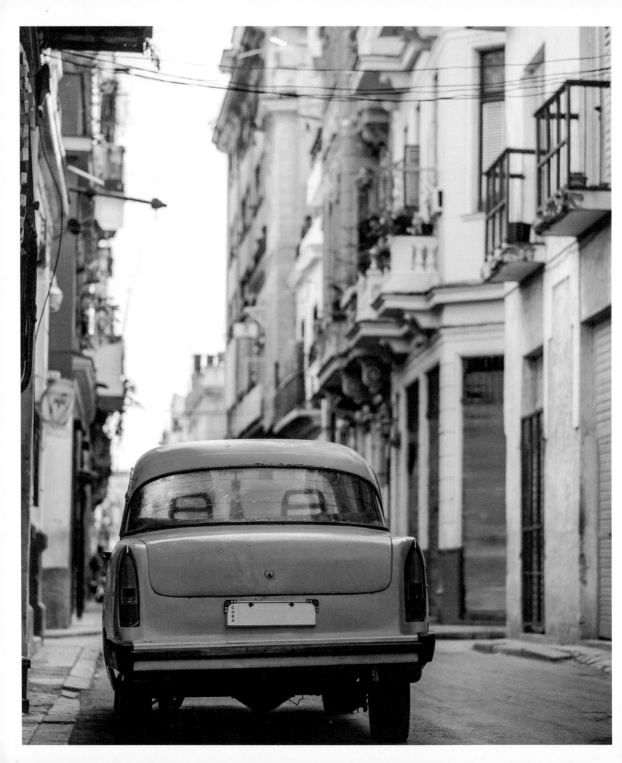

Havana, CUBA

THIS CITY IS FILLED WITH COLOR, FROM THE CARS OF THE 1950s TO the buildings' decrepit candy-painted facades. Imagine the streets: drum rhythms floating in the air as boys practice their best shot at baseball—a beloved national sport—and men play dominos while a couple walks by on their way to the Havana waterfront to take in a Caribbean sunset and maybe perform a few steps of salsa to dance the night away. Go see a ballet at the Gran Teatro de la Habana Alicia Alonso. Follow the traces of Ernest Hemingway. Visit the Museum of the Revolution, a tribute to Cuba's sovereignty. Now that Cuba is opening its doors, things are bound to change.

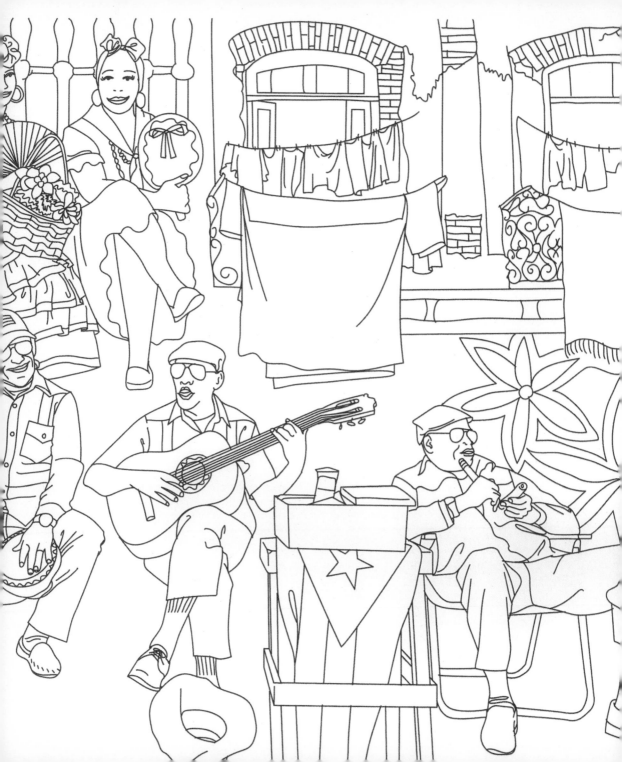

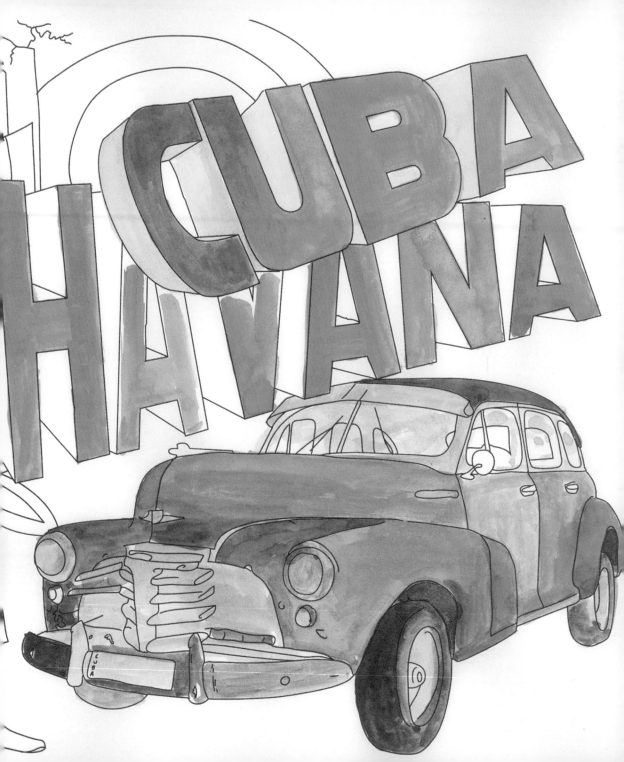

Despite years of restrictions on artists,
Cuba enjoys an exciting and thriving cultural scene.
The Havana biennial, held every three years, is
the occasion to see contemporary artworks.

FILMS TO SEE

Buena Vista Social Club
(Wim Wenders)
21 Viva Cuba
(Juan Carlos Cremata)

BOOKS TO READ

Our Man in Havana (Graham Greene)
Before Night Falls (Reinald Arenas)
The Old Man and the Sea
(Ernest Hemingway)
The Mambo Kings Play Songs of Love (Oscar Hijuelos)
Explosion in a Cathedral
(Alejo Carpentier)

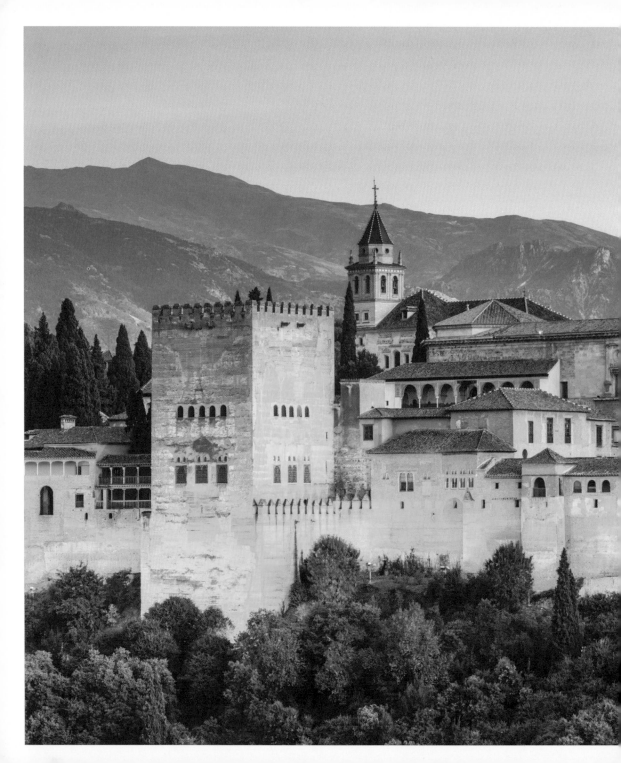

Andalucia, SPAIN

HEAD TO THE SOUTH OF SPAIN TO LOOK AT THE EXQUISITE PALACE of the Alhambra. Andalucía is a region famous for its iconic Moorish architecture, such as La Mezquita, an immense Mosque adorned with Byzantine mosaics. It is famous for its wonderful local cuisine too, such as gazpacho, fried quail eggs, and jamón Ibérico ready to carve. Then make it to the Andalusian capital, Seville, to go on a tapas crawl (which will take you all over town and throughout the night) and make sure to head to the old Gypsy district of Triana to watch a flamenco show. Now you are ready to go see an even more mesmerizing dance: la corrida—a bullfight!

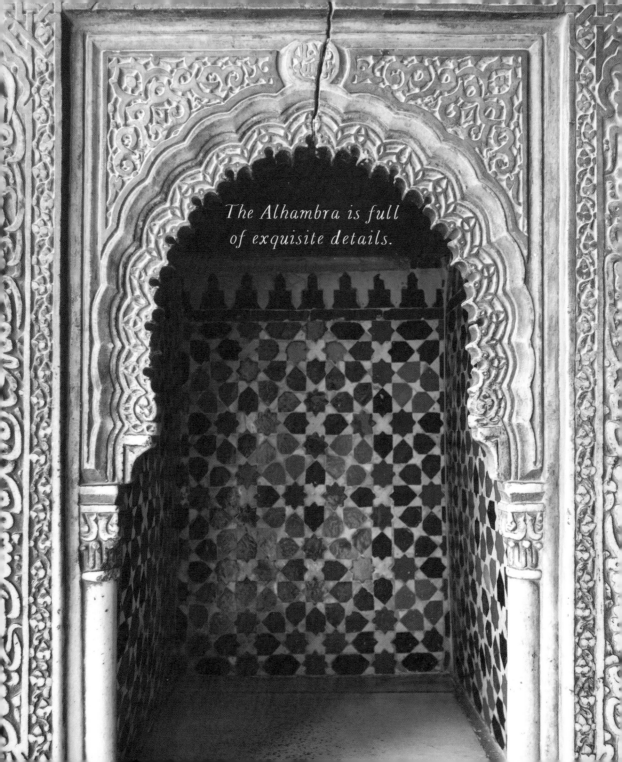

The Alhambra is full
of exquisite details.

Gazpacho

Have you ever made gazpacho?
This recipe from Seville is very tasty and easy.

Makes 8 to 10 servings

5 medium tomatoes, cubed
1 cucumber, peeled and cubed
1 green pepper, cubed
1 clove garlic, minced
1 onion, finely chopped
¹/₂ cup olive oil
Salt and pepper, to taste

Add all the ingredients in a mixer and turn everything into a smooth purée. The color should be more orange than red, which comes from adding olive oil. Serve chilled.

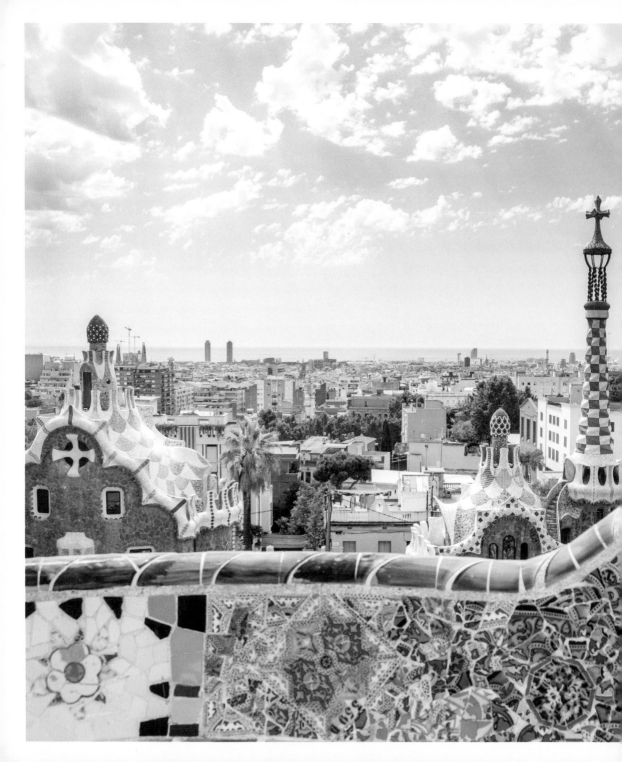

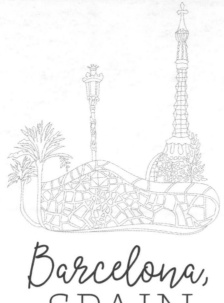

Barcelona, SPAIN

THIS CITY IS A FEAST OF COLORS AND SUCH FUN TO EXPLORE! THE buildings created by Gaudí are quirky and almost organic in shape, with exquisite mosaics. Check out the aquarium to see an amazing collection of marine life. And in the evening, stroll the streets to sample tapas as the notes of a guitar fill the night.

Inspired by the modern mosaic of Gaudí?
Create your own mosaic pattern right here:

There is too much to see on
La Rambla to take a siesta!

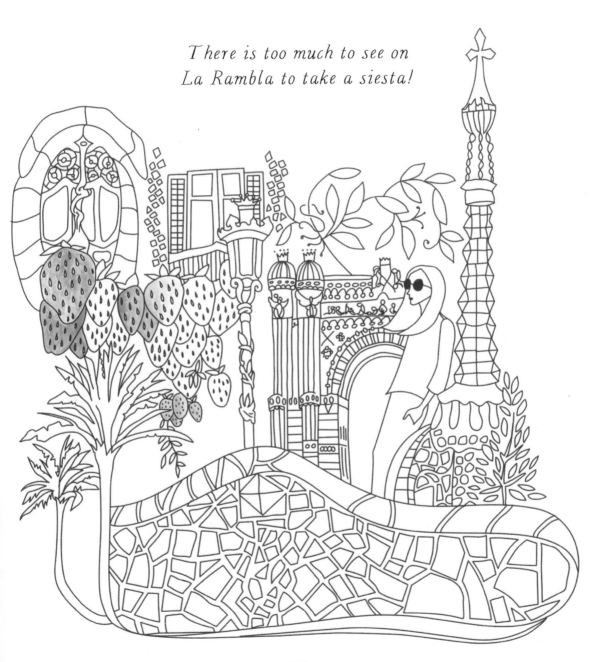

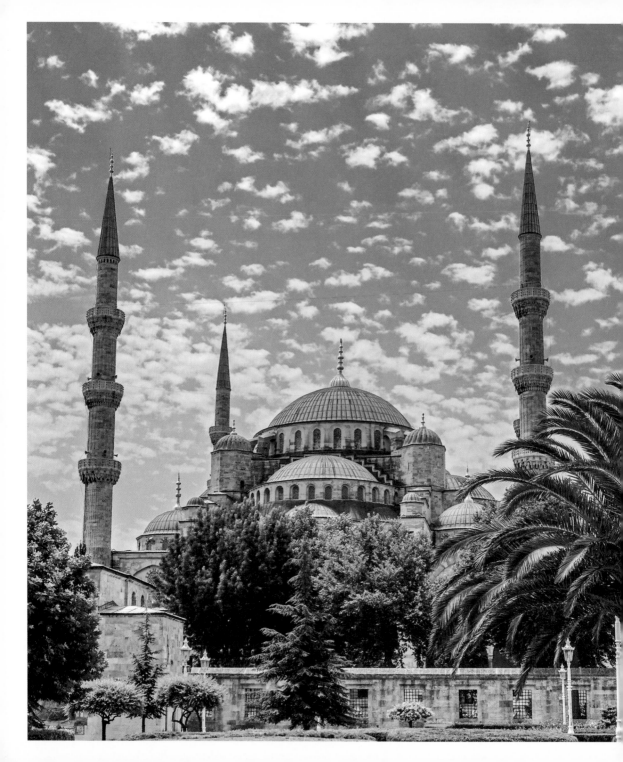

Istanbul, TURKEY

THE TURKISH METROPOLIS IS DIVIDED BY THE BOSPHORUS: ONE half is in Asia, the other in Europe—one city on two continents! You can learn about Byzantine history and listen to Turkish jazz. The historical neighborhood of Kuzguncuk, paved with cobblestones, still boasts a synagogue, a Greek Orthodox church, an Armenian church, and a mosque. Try sour cherry bread pudding or rosewater milk pudding and savor a cup of Turkish coffee served on an etched-brass tray.

Spend hours browsing in Sahaflar Çarçsisi, Istanbul's used-book bazaar. The Turkish writer Orhan Pamuk wrote a beautiful book about the city, filled with charm and melancholy. He even created a museum based on a novel he wrote, *The Museum of Innocence*, which evokes daily life in Istanbul and the fascination of the narrator for a woman he loves.

One foot in Asia, one foot in Europe.
Let's go look at the Blue Mosque...

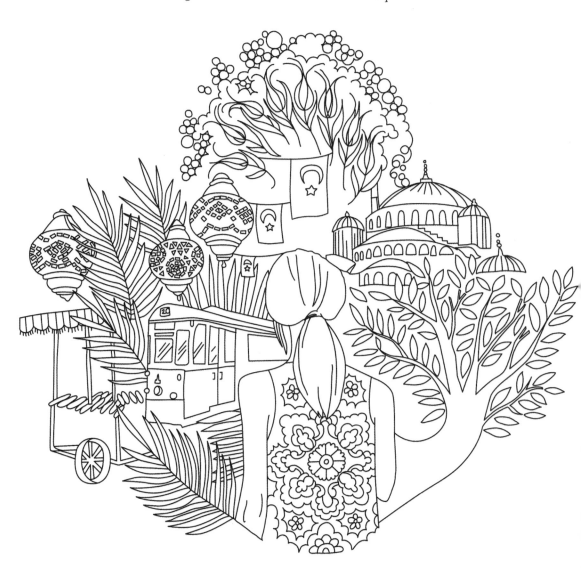

Then go shop for treasures in the Grand Bazaar,
like these gorgeous Turkish carpets.

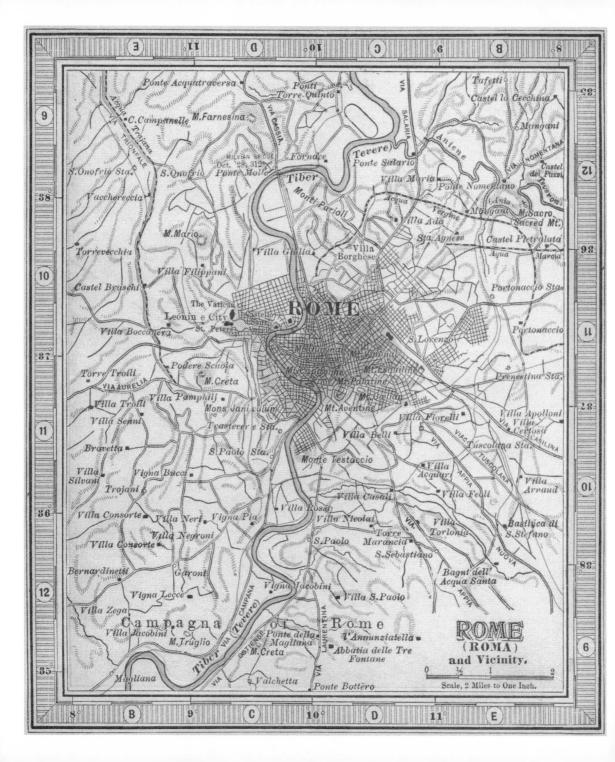

ROME
(ROMA)
and Vicinity.

Scale, 2 Miles to One Inch.

Rome, ITALY

THE ETERNAL CITY IS A TREAT FOR HISTORY LOVERS! THE FORUM, the Colosseum, and the Pantheon are testaments to Rome's historical legacy. Walk along the eerie catacombs. Take a stroll down the Appian Way and breathe in the scent of cypress trees. The road was built in 312 BCE by the Roman censor Appius Claudius Caecus to facilitate the transport of military supplies. Look up in the Sistine Chapel as you admire Michelangelo's masterpiece across the ceiling. Wherever you find yourself in Rome, you are surrounded by beauty: fountains by Bernini, sculptures by Michelangelo, frescoes by Rafael. After a day filled with history and art, do as the Romans do! Find a trattoria for an *aperitivo* in Trastevere, and dine *al fresco* while enjoying a traditional Roman dish like *cacio e pepe*, a pasta tossed with finely grated pecorino romano and coarsely ground black pepper, or a carbonara or *gnocchi all'amatriciana*. Delicious! And if you are a film buff, take a stroll around Cinecittà, the hothouse of Italian cinema.

FILMS TO SEE

La dolce vita (Federico Fellini)

Roman Holiday (William Wyler)

The Bicycle Thief (Vittorio De Sica)

Gladiator (Ridley Scott)

La grande bellezza (Paolo Sorrentino)

BOOKS TO READ

The Woman of Rome (Alberto Moravia)

The Ragazzi (Pier Paolo Pasolini)

SPQR (Mary Beard)

The Leopard (Giuseppe Tomasi di Lampedusa)

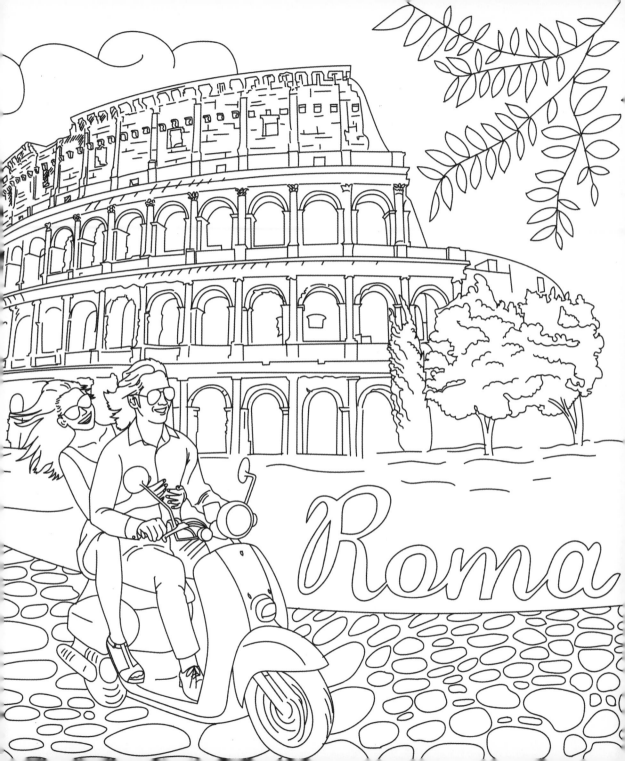

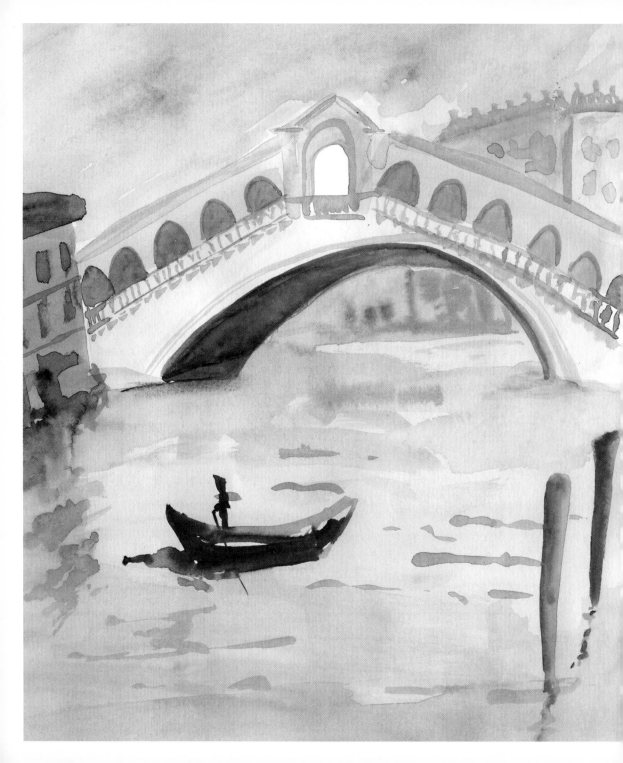

Venice, ITALY

A RIDE ALONG THE CANAL GRANDE IS A BREATHTAKING EXPERIENCE!
Imagine a whole city built on water, a palazzo with an exquisite facade of intricately carved stones—the light glimmering on the glass panels of the windows and on the blue-green water. Venice is a city filled with treasures, old and new, rare and well-known: Titian, Tintoretto, and memento mori jewels favored by Jean Cocteau, Peggy Guggenheim, and Coco Chanel. The city is like a labyrinth and getting lost is very much part of its charm. After so much walking around, stop for *cicchetti* by the canal. These are small snacks served at the counters of bars, like little sandwiches or a bowl of olives. And when the day draws to a close, watch the sun set over the laguna and admire the stone facades as they turn a deeper shade of pink.

*Each year, in the lead up to Shrove Tuesday,
the Carnevale di Venezia takes place across the
whole city and people put on elaborate masks and
costumes. Imagine your ideal costume for the
Venice carnival! What would your mask be like?*

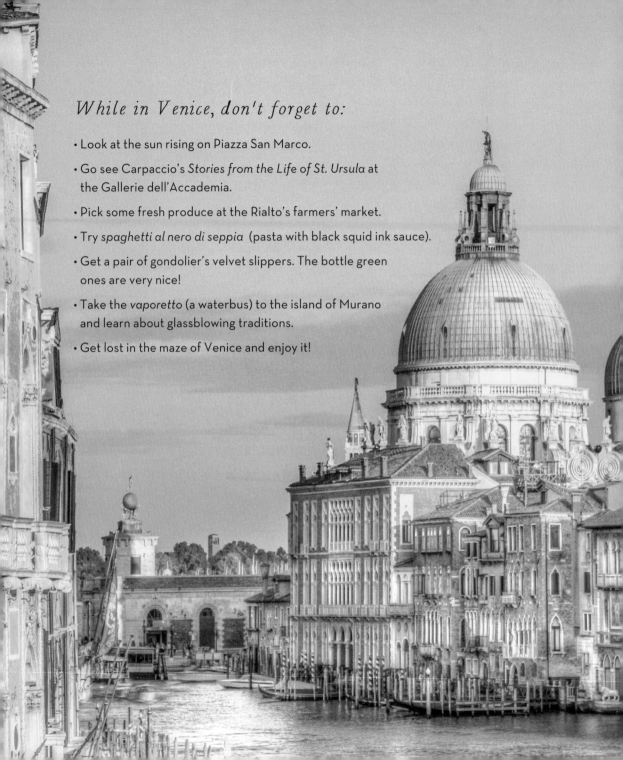

While in Venice, don't forget to:

- Look at the sun rising on Piazza San Marco.

- Go see Carpaccio's *Stories from the Life of St. Ursula* at the Gallerie dell'Accademia.

- Pick some fresh produce at the Rialto's farmers' market.

- Try *spaghetti al nero di seppia* (pasta with black squid ink sauce).

- Get a pair of gondolier's velvet slippers. The bottle green ones are very nice!

- Take the *vaporetto* (a waterbus) to the island of Murano and learn about glassblowing traditions.

- Get lost in the maze of Venice and enjoy it!

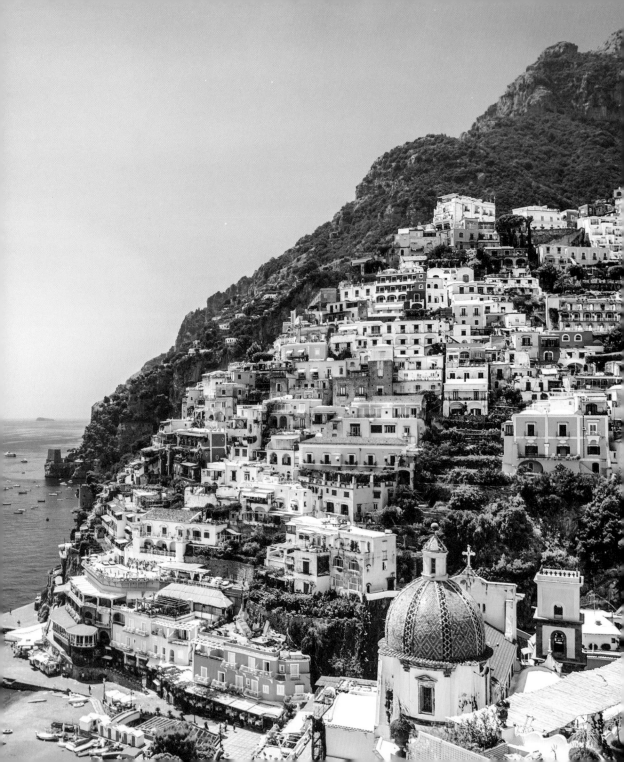

Amalfi Coast, ITALY

THIS IS ONE OF THE MOST BEAUTIFUL PLACES ON EARTH! LOCATED IN the south of Italy, the Amalfi Coast is a jewel of the Mediterranean. Think gleaming blue sea and little fishing villages. The houses are pastel pink, crimson, and ochre, dappled with hot pink bougainvillea flowers. When night falls, the air smells sweetly of lemon. Take a scenic drive on the winding road along the coast—the view is magnificent but also dizzying as you zoom along the cliff. Start in the Bay of Naples, admire the Vesuvius volcano, and you will reach Amalfi, Positano, and Ravello—towns that have inspired artists for centuries. Bring home some local souvenirs, such as linen dresses, leather sandals, or beautiful ceramic objects.

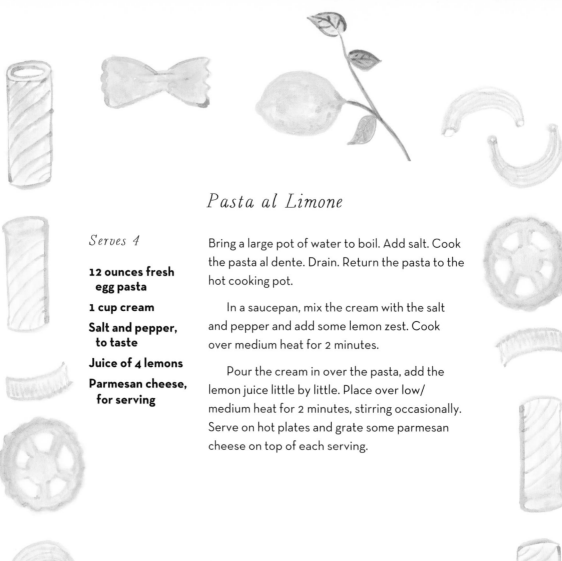

Pasta al Limone

Serves 4

12 ounces fresh egg pasta

1 cup cream

Salt and pepper, to taste

Juice of 4 lemons

Parmesan cheese, for serving

Bring a large pot of water to boil. Add salt. Cook the pasta al dente. Drain. Return the pasta to the hot cooking pot.

In a saucepan, mix the cream with the salt and pepper and add some lemon zest. Cook over medium heat for 2 minutes.

Pour the cream in over the pasta, add the lemon juice little by little. Place over low/medium heat for 2 minutes, stirring occasionally. Serve on hot plates and grate some parmesan cheese on top of each serving.

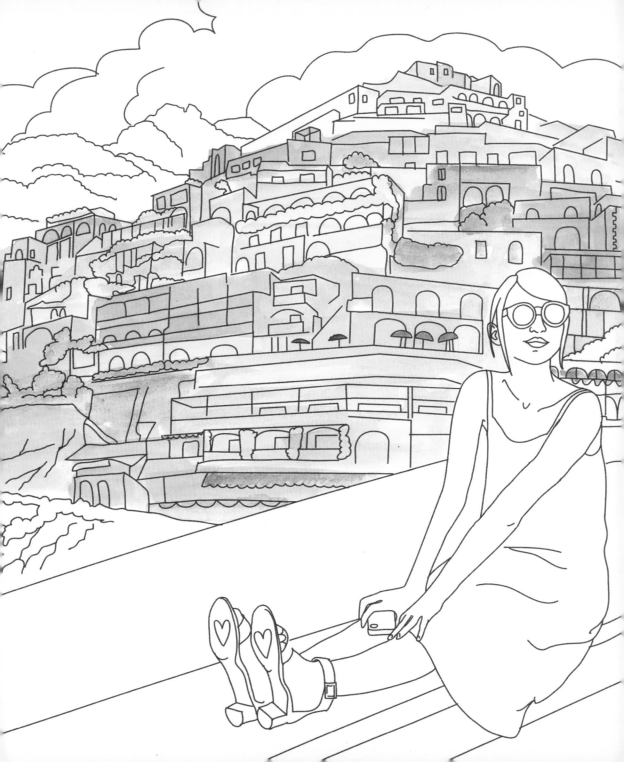

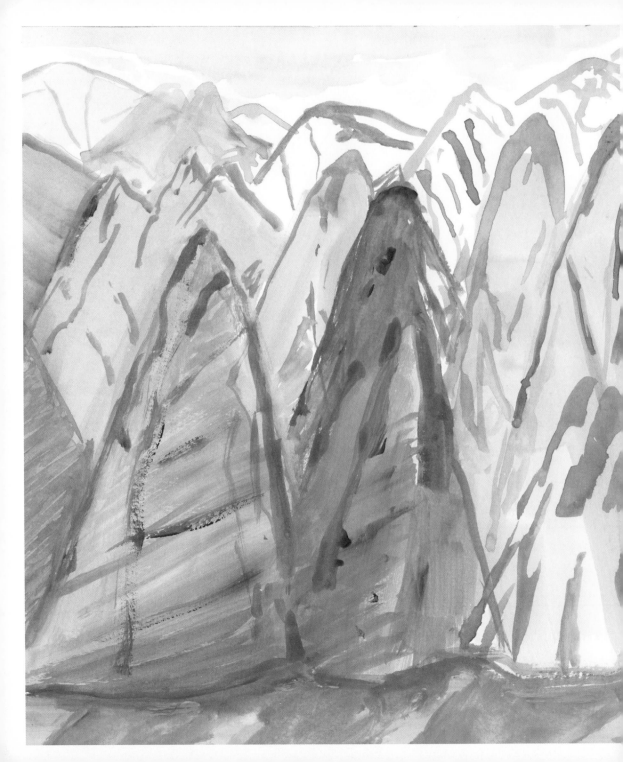

CHILE

CHILE IS LOCATED BETWEEN THE PACIFIC OCEAN AND A RANGE OF mountains, the Andes, which are both natural barriers. The nation's capital, Santiago, is buoyant with activity and filled with dreams. In Chile one can see the most extraordinary colors: the dark red of the Mapocho River carrying red dust from the Andes and crossing the capital, the glaciers' incredible turquoise color, and the silver light of the sea around the island of Chiloé at dusk.

In the northeast lies the Atacama Desert, a place that truly inspires wonder! It is known to be the driest place in the world. With its clear sky and high altitude, it is a perfect spot to go stargazing. The region boasts some of the world's most powerful telescopes, attracting scientists and star-lovers from all over the world. Gaze through one of these telescopes and you can even see the rings of Saturn and a map of spectacular constellations.

Once every five to seven years when it rains in the Atacama Desert, pink flowers bloom everywhere, covering the desert in all shades of pink. It's called the *desierto florido*—the desert in bloom. Can you imagine this arid and dusty place suddenly covered with millions of red and pink flowers?

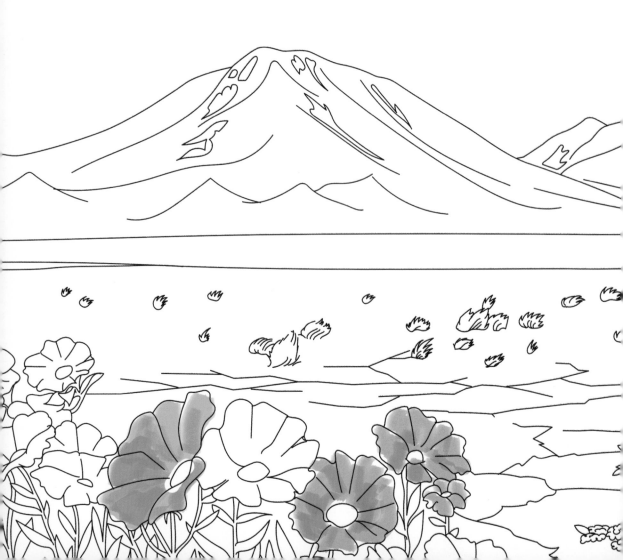

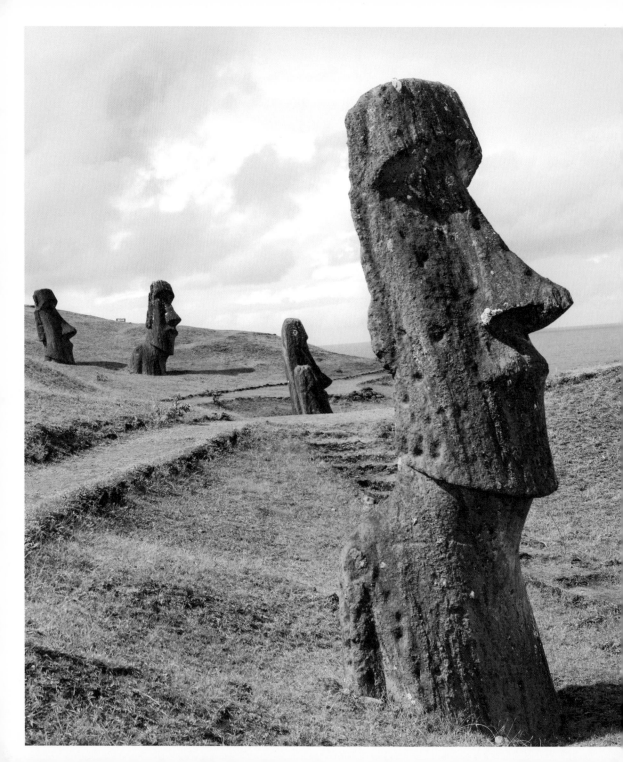

Easter Island, CHILE

MOAI, THE HUNDREDS OF MONOLITHIC STATUES DEPICTING HUMAN figures are found all over Easter Island. Some stand in neat rows, their backs to the ocean, guarding the island from invaders; some are now slumped to the ground. They were built by the early Rapa Nui people. Did they represent gods? Or mythical figures? Perhaps ancestors?

It is hard to imagine how anyone managed to carry such heavy stones, as each weighs an average of twelve tons. (The largest one is eighty-two tons!) Maybe trees were used to sledge the stones that were then tilted and pulled from side to side with ropes. According to oral history, the statues were made to walk by an order of King Tuu Ku Ihu, while other legends say a woman living alone in the mountains ordered the statues to walk. What's your theory?

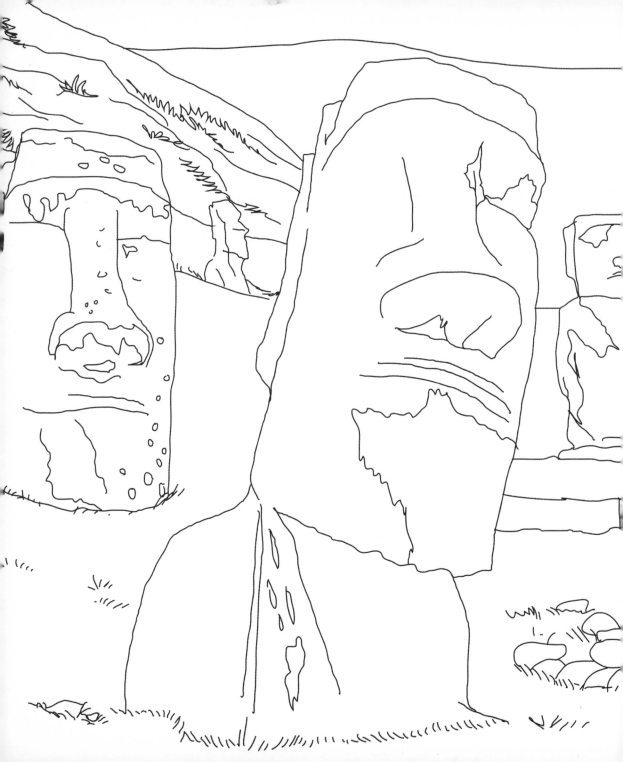

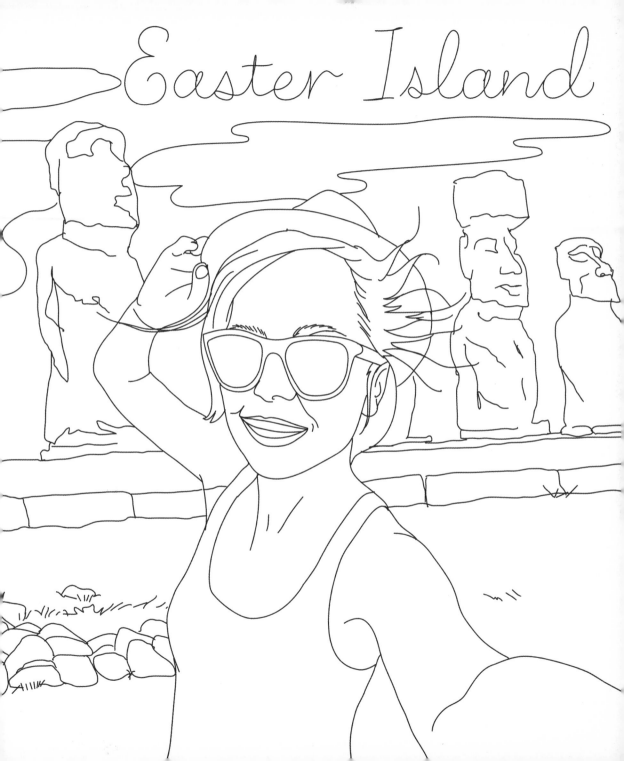

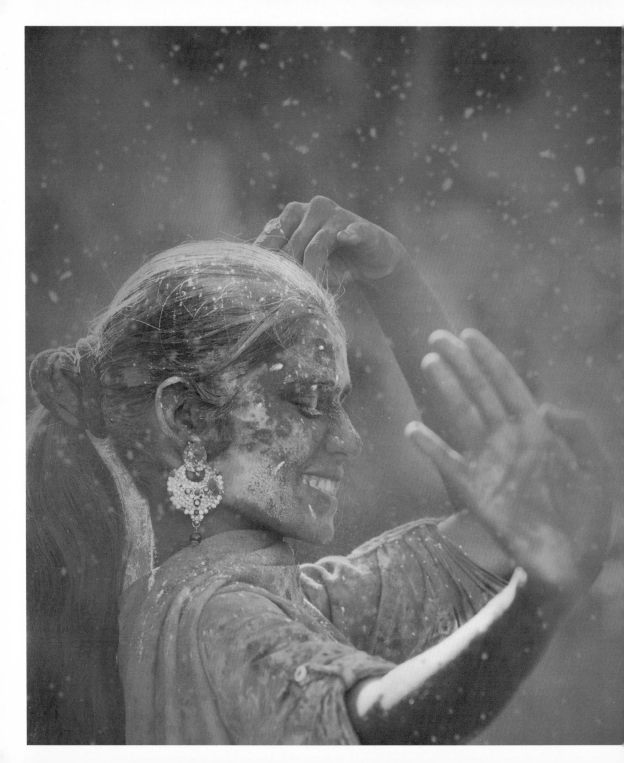

INDIA

THE TAJ MAHAL MAY WELL BE INDIA'S MOST FAMOUS MONUMENT.
It is referred to as a "poem in stone." Emperor Shah Jahan built it for his late wife
and said it made "the sun and the moon shed tears from their eyes." India is such a
vast country. You could spend months exploring its many regions. Look for gems in
Jaipur, also nicknamed the Pink City. Fight your way through traffic in Mumbai. Don't
be afraid of the crowds; this city is constantly busy! If you need a moment to yourself,
you can always practice yoga and meditate. Or admire the rich colors of this country,
from the pink, blue, and yellow saris worn by women to the blue god Ganesha. Take
part in the Hindu spring festival of Holi—the festival of colors, which celebrates the
arrival of spring and the victory of good over evil. As the drums roll, people start
dancing and smearing one another with colors while laughing.

To get a glimpse of India from home, watch *The Apu Trilogy* by Satyajit Ray
and read Salman Rushdie's *Midnight's Children* or Arundhati Roy's *The God of
Small Things*.

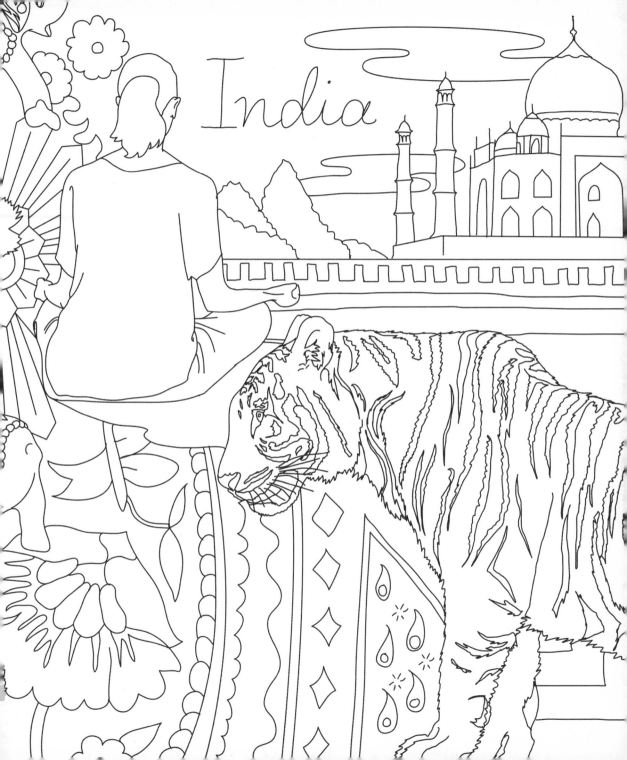

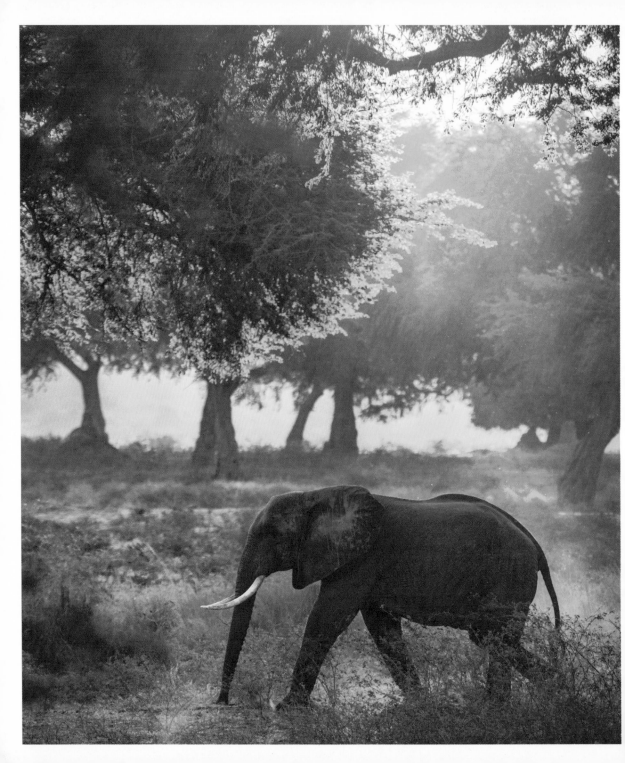

ZIMBABWE

A SAFARI IN SOUTHERN AFRICA IS THE TRIP OF A LIFETIME FOR WILD-
life aficionados. Zimbabwe is a landlocked country. Lions, leopards, rhinos, elephants, buffaloes, and giraffes roam different parts of the numerous national parks. But deforestation and poaching are now huge threats to these magnificent animals. At the border of Zambia and Zimbabwe lies Lake Kariba—one of the world's largest man-made lakes and reservoirs. It's surrounded by the shapes of trees near the lake that look almost animal-like.

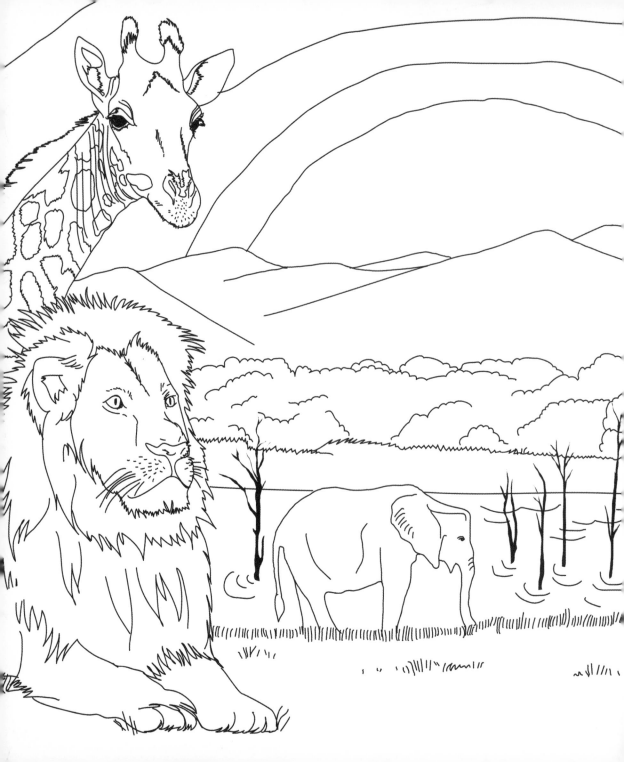

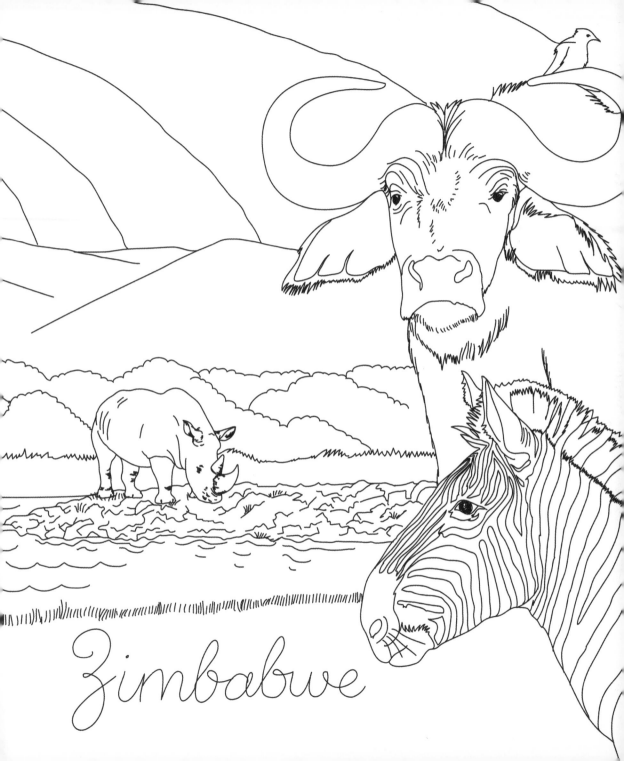

Zimbabwe

MAKE YOUR
OWN PATH!

THE FOLLOWING PAGES ARE AN INVITATION TO DREAM UP YOUR OWN
adventures wherever you wish.

Draw the land of your dream destination
as you spot it from the window of an airplane.

What's your favorite ice-cream flavor?
Draw the setting where you want to
enjoy the first cone of the summer...

Mountain or beach?

City or wilderness?

TIME

IF YOU TRAVEL A LOT, AS PILOTS DO, YOU MAY BECOME IMMUNE TO
jet lag. But time differences can be tricky. As with daylight savings time, when you
wake up too late or too early. . . . Imagine that the clock went back not one hour but
twenty-four, and that you gained a whole day to yourself! What would you do with this
precious extra day?

TOKYO

NEW YORK

LONDON

Where is your happy place? What does it look like?

What are your favorite things to do there?

Where would you like to go next?

WHAT IS UNIQUE ABOUT THIS PLACE? Is it the food? The music? The colors that surround you? Maybe it is the sense of history . . . or the rare animals? Maybe it is simply a place that has always captured your imagination.